INNER HERO

CREATIVE ART JOURNAL

mixed-media techniques
to silence your inner critic

Quinn McDonald

NORTH LIGHT BOOKS
CINCINNATI, OHIO
artistsnetwork.com

Contents

YOUR INNER HEROES

Art journaling has so much flexibility—work in spiral or hardback; write with ink or pencil; fill pages with collage or paint; use original writing or quotes. All that flexibility gives you freedom to do backgrounds ahead of time or just in time. You can jump into bright colors or deliberately choose monochromes. However, all these choices don't always add up to joy and satisfaction. Sometimes, after you've made your choice, you feel you have shut the door on all other possibilities, and you immediately begin to miss those lost chances at different outcomes. That's when your inner critic shows up to give you advice about what you *should* have done.

Most comments your inner critic makes will encourage you to start something new, take a break or get serious about your lack of talent or creativity by switching from one medium to another. You can run from the inner critic, but you can't hide.

Stop running. It's time to take a stand. That's why I wrote this book. Not to help you chase the inner critic out of your life. Not to dig a deeper hole in which to hide. This book is about sitting down with your inner critic and calmly listening, deciding on your truth and then replying to your inner critic with a strong voice of conviction that honors your creativity. And doing it all through art journaling.

You are not alone at the worktable with your inner critic. With you are your *inner heroes*—those parts of you that are brave and strong and talented and seldom get a voice. This book helps you discover your inner heroes, call them to you, hear them out, and let them confront your inner critic for you. You'll discover this new idea and how to call out your inner heroes in the first chapter, "Breaking the Ice."

By the end of the first chapter, you'll also notice that the book is based on an entirely new way to art journal—by using loose-leaf pages. You'll create art on one side and write on the other. You can make pages one at a time, or do a lot of writing when you feel like exploring your heart and spirit, and design when you want to express yourself in color, texture and shape.

No more creating backgrounds and then deserting them. No more blanking out when you want to write or wishing you could find a new way to show your ideas—the second through the sixth chapters have both an art technique *and* a writing technique.

You can collect the pages you like and want to share separately from the ones you aren't sure about. You can

4

ARE ALWAYS WITH YOU

separate private pages from those you show. You might want to peek at the last chapter to see how to make inventive, useful holders for the pages.

The pages you make won't sit on the shelf once you're done. These pages are meant to be used again and again to make meaning of your journey, to help your inner heroes show up when they are needed and to nudge your creativity into exploration mode. The seventh chapter has ideas on how you can use the cards, by yourself and in groups, to inspire, to throw creative sparks and to encourage your inner heroes to speak up when the inner critic shows up. It also has an interview with an amazing Native American artist, David Dawangyumptewa. His story is about healing, art making and meaning making. I hope you'll be inspired by his interview.

Each chapter shows a loose-leaf page made by a contributing artist. They are not samples; they are possibilities and inspiration. Contributors didn't follow a set of directions to demo what you should do; they show you the different directions, ideas and the inner heroes other artists created. Contributors also share how they talk to

their own inner critics. This book is not about following a sample; it's about encouraging you to create ideas of your own. Your inner critic is uniquely yours, and so are your inner heroes. But you'll read more about that soon in the first chapter.

As in my last book, *Raw Art Journaling: Making Meaning, Making Art*, you do not have to be an illustrator, professional artist or writer to use the book. Although if you are, you may well find it inspiring and useful and discover new creative boosts. This book assumes your creative cup is not full. If your creative cup is already full, then one more exercise, one more idea, one more project will cause it to overflow and lose content. This book is for meaning-makers, seekers and those who want to step up to their inner critic and find a voice that explains who their inner heroes are.

Each chapter, each hero, art technique and writing project is a starting point. Take the ideas and transform them. Let them help you understand your heart, explore your mind and discover your path in life.

I wrote the book for anyone who strikes sparks of light and wants to fan sparks into a flame. If that's you, step out of the shade and into the warmth and comfort of your own light. It's bright enough to see your journal and make meaning with *Inner Hero Creative Art Journal*. Turn the page and dive in.

MATERIALS EXPLORED

surfaces

• fabrics: sheers, butterfly prints, printable fabric
• papers: white paper, colored paper, freezer paper, parchment paper, index cards, black cover stock, sketching paper (80- or 90-lb. [170- or 190gsm]), watercolor paper (e.g., Strathmore Ready Cut, Arches Velin)
• shelf liner

mediums

• gel medium, matte or gloss
• inks: dye-based, pigment, stamp pad re-inkers (dye- or water-based), acrylic, metallic, spray-glitter (e.g., Glitter Mist)
• permanent markers
• watercolor paints
• pencils: 2B pencils, watercolor pencils
• pens: your favorites for writing and drawing (e.g., Faber-Castell Pitt or Micron), colored pens, gel or glitter pens, waterproof pen, water pen, brush pens (gray and brown)

IN THIS BOOK

tools

- bone folder
- brushes, watercolor or acrylic, various sizes
- cutting mat
- drying rack or drop cloth
- eyedropper or pipette
- iron and ironing board
- palette, a 3" (8cm) plastic lid
- paper cutter or craft knife
- rubber stamps
- ruler or straightedge
- scissors
- sea sponge
- sewing machine
- spray bottles: small (e.g., Mini Mister) and medium
- straws or hollow coffee stirrers
- tapestry needles, size 18
- timer

other supplies

- book repair tape
- box of words
- buttons
- eggshells
- elastic, round
- eraser
- fibers, soy silk or mulberry silk
- fusible webbing, clear, white and black
- glues: polyvinyl acetate (PVA), white glue, glue sticks
- hardcover book
- journal
- leaves, dried and pressed
- magazines with colorful ads
- paper towels
- peacock feather
- photograph copies
- ribbon
- salt, kosher or medium (4mm) crystals
- seed packet template
- thread: assorted colors, pearl cotton size 5
- water, distilled or tap (for rinsing brushes)

SELL

YOUR

CLEVER-

-NESS

AND

BUY

BEWILD ER MENT

-RUMI

BREAKING THE ICE

Your Journal, Writing, Art, Wisdom & Creativity All Come Together

Calling up your inner heroes is the purpose of this book. You are going to create 5" x 7" (13cm x 18cm) loose-leaf pages, a stack of creative responses to your inner critic. They are loose-leaf so you can choose the inner hero who needs to confront the specific attacks of your inner critic. You are going to build a powerful stack of pages to use like a tarot deck every time you feel weak, unsure and afraid of your own creativity.

The pages—5" x 7" (13cm x 18cm) pieces of watercolor paper—will help you talk through negative emotions, destructive comments and hurtful directions. They will clear the air so you can get back to deep creative work.

What will you put on the cards? You'll do deep writing exercises and find your inner heroes' voices and skills. You'll also learn a variety of art techniques—and variations—to help you remember who your heroes are and what you have in common with them.

Each 5" x 7" (13cm x 18cm) card will have an image on one side and writing on the other. The writing will remind you about a skill, talent or characteristic you have that makes you a hero. The art side will remind you of some part of the hero—a color, a shape, an image that inspires you to stay brave and be courageous about your creative work.

Each chapter has two parts, one about an art technique and one about a writing technique, so you can begin to create a whole deck of inner hero pages that will become your Inner Hero Art Journal.

The best part is that none of the exercises in the book require you to know how to draw, illustrate or be any more than you are already—creative, whole, and ready to explore the world within you.

But before we begin making the cards, we need to call out our inner heroes, and before we do that, let's spend a bit of time getting to know your inner critic . . . you know, break the ice.

Your Ever-Present Inner Critic

A fish out of WATER

The inner critic. You've heard the name, and you've felt the bite. Maybe you have even let your own inner critic make decisions for you.

"No, I can't do that, I'm not talented enough."
"Why does she get all the breaks?"
"That will never sell. I have to work on this, because this will be more popular."
"It's not what you know, it's who you know, so I might as well give up."

Sound familiar? That's your inner critic, and whether you call it negative self-talk, the shadow side, rational logic, the superego, the devil on your shoulder or your dark voice, it's a very real part of your decision making, including what you decide to create.

The Inner Critic Is as Real as You Are

The inner critic is a real part of our neurological and psychological makeup. Everyone has one. (Mine shows up as an angry guy in an expensive suit, with a big, loud, sarcastic and demanding voice, so throughout much of our time together, you will hear me refer to the inner critic as "he.") He goes everywhere with you and he comments on your work, whether you ask his opinion or not.

Your inner critic is not always wrong either. There are things you can't do, no matter how much you want. For most of my life, I wanted to have a beautiful soprano singing voice. I have a fine alto speaking voice, but I can't sing on pitch or even in one key for very long. I've practiced and I've had lessons, but as my third-grade teacher so wisely said, "Not everyone can sing. Some of us need to applaud the ones who can sing." I'm one of the applauders. So when it's time to sing the national anthem at a baseball game, my inner critic hisses, "Don't you dare," and I know he's right.

When your inner critic says you can't do something, it's worth thinking about—not taking it as truth or reality, but at least listening. As jewelry artist Luann Udell says, "The inner critic comes to all my art shows with me, but he has to sit in the backseat. I never let him drive."

WORKSHEET: getting a grip on your inner critic

You can't face your inner critic without having a clear idea of what he (or she) says and what he or she looks like. Check off the things your inner critic says to you:

o What makes you think you can do that?
o You don't have the talent to do that well.
o Shouldn't you have a degree to do that?
o Another term for *self-taught* is *not talented*.
o Who would be interested in that?
o What kind of person thinks this project would ever be a good idea?
o Who are you to do that?
o It's not what you do, it's who you know, and you don't know anyone important.

Fill in the blanks with the inner critic's top cruel remarks:

See? You screwed up. You know that means _____

This is the second time you tried this. Don't you know _____

You've never had enough to be called a real _____

Even when you were a kid, your parents didn't _____

 to make sure you felt _____

What kind of an idea is that? You can't expect to be _____

 as long as you are so _____

Your inner critic in five senses:

How do you feel when your inner critic is criticizing you?

How do you look at your art when the inner critic says it's worthless?

What phrases you hear when the inner critic is around?

What long-forgotten shame or guilt does the inner critic sniff out when you are working?

When you look at your creative work with the inner critic, it will always leave you with a bad taste about your skills. What are the worst self-criticisms?

Now you know how your inner critic shows up for you. This will be important when you call on your inner heroes to confront the creativity wrecker for you. You'll also need this worksheet to know which one of your inner heroes is needed for the task.

You can download more worksheets at www.artistsnetwork.com/innerherocreativeartjournal.

Putting a Face on Your Inner Critic

To recognize your inner critic, make an image of him or her or even it. You can draw, collage, write, paint. But do something with your creative toolbox that makes the inner critic come into sharp focus for you.

There are three good reasons for doing this:

1. You are creative, and making art is how you think, plan and explore your emotions. You don't want to quit because of bad directions from your inner critic.

2. Making a representation of the inner critic moves him away from you and onto a piece of paper.

3. Once the inner critic is on a piece of paper, he is separate from you rather than a part of you that directs your thoughts.

You can use the inner critic as one of the loose-leaf pages you are going to make in this book. All the other pages will be about your inner hero, but it is useful to have the inner critic card for contrast and brainstorming.

Creative Life Still Exists After the Inner Critic Appears

The general wisdom used to be that the inner critic was always wrong, needed to be ignored and chased out of the studio. In my first book, *Raw Art Journaling: Making Meaning, Making Art*, I had a list of suggestions on how to keep the inner critic out of the studio. Chasing him out works, but he always comes back. Waiting for him to come back creates another problem. You wind up patrolling the edges of your thoughts—just in case he shows up—making sure he stays out. You begin to wait for him and look for him. Eventually, seeing your inner critic is a relief; he finally shows up! That takes away creative time and energy and makes you tired and anxious. Not the best state for doing creative work.

And that's a big problem.

You can't concentrate if you are patrolling the borders, waiting for a sign of the returning critic. You can't get into flow—that deep, timeless space that you swim in when you *do* creative work—if you are keeping part of your awareness on the alert for the inner critic.

Yes, he'll come back. But if you keep looking for him, he'll come back faster. Once you start looking for him, he'll be everywhere. It's exhausting.

So now what?

Calling Out Your Inner Heroes

Let's leave the inner critic for a while and talk about you. (He'll still be there when you get back.) Despite yammering from the inner critic, you know what you are good at. You might not brag about it, but you are good at a lot of things. Maybe it's organizing a schedule, or being there for a friend when they need you. Maybe you have a beautiful singing voice, have a thriving garden or work quickly under pressure. Maybe you have a good sense of direction, can squint at math problems and solve them or can make watercolors flow into incredible artwork.

Whether you admit it out loud or not, you have talents, strengths and ways of handling your life that are useful and efficient.

"Oh, sure, I'm the dependable one in the family."

"Well, of course I have the photos of Mom's sixty-fifth birthday party; I'm the family archivist. Ask me about my scrapbooks!"

"Youngest kids always have the sense of humor. It's been a plus since I've had this job."

Your talents and abilities can be represented by inner heroes—and we all have inner heroes. You recognize your inner critic quickly, but your inner heroes need to be called out and recognized so you can see them clearly as well. What does an inner hero look like? A lot like you with your talents emphasized.

Do you tell stories to people to make them feel better, laugh or understand one of the hard bumps in life? You might have an inner hero storyteller glowing within you.

Do you have a green thumb, a garden that feeds your family and neighbors? Your inner hero could be the nurturing gardener—the one who also nurtures bruised hearts, hurt feelings and tentative first steps in others. A gardener inner hero doesn't have to stick to the garden outside. She can also weed out injustice, nurture tender new creative ideas or appreciate the under-appreciated in a life.

Naming Your Inner Heroes

Let's begin distilling down the thoughts you have so we can name your inner heroes. First, find a timer and grab a pen and a journal. Set the timer for one minute and, writing as fast as you can, without thinking too much, answer this question:

If you could have any power, what would you choose? (This doesn't have to be a super power; it can be a deep-felt power, such as being a good listener. Or something you think you have a little of and want a whole lot more of.)

If that still feels uncomfortable, do this instead:

Name ten real (or made-up) heroes that you would like to spend a day with making art, or maybe invite to dinner, or both. You can name heroes from books or movies or simply who they are.

Some examples:

• Magician
• Inventor
• Time Traveler
• High Priestess from the tarot deck (represents mystery and vision)
• Earth Mother
• Alchemist
• Cartographer (charts unexplored places)
• Wounded Healer (one who heals from power of her own wounds)
• Mender of Hearts
• Problem Solver
• The Fool (wise person in disguise, often makes people laugh or cry)
• Pilgrim or Pioneer
• Painter (who makes life come alive)
• Needle Woman (who uses scraps to create something new)
• Magical Child (enchanted/enchanting, forever escaping a spell or creating one)

WORKSHEET: my heroes

Once you have the list of heroes and have invited them into your life, list them in the first column of this worksheet. Look at them and see how they are like you. They don't have to be just like you, but you absolutely have something in common. Put that in the second column. Maybe you and your inner gardener know just when to start planting (an idea, a friendship or a seedling). What are the best things about both of you?

In the third column, write down ideas you would spend time talking about with your inner hero. Notice that both column two and column three take the idea of the inner hero and transfer it to your creative life and the art you make.

You can download more worksheets at www.artistsnetwork.com/innerherocreativeartjournal.

potential inner heroes	how are you alike?	what do the two of you need to discuss?
Gardener	Patient, like to see things grow, know that pruning is important to keep new growth coming.	Fast, colorful ideas vs. slow-growing but long-lasting ones. (Annuals vs. perennials)

Bringing Your Inner Heroes Into Your Life

You probably have a strong idea who your inner hero is, but you may be hesitant to think about it or admit it. After all, if you admit that you can be a hero—that you have strong points, good ideas and creative power—you may have to accept it and live up to it.

It's OK if you feel you have to grow into your hero. It's OK if you feel a bit like a villain, too. Acknowledging that you have heroic moments is enough to begin with. Give yourself permission to be your own hero; it's a wonderful feeling.

Inner Heroes' Other Identities

Inner heroes and inner critics aren't new. Many cultures have folklore rich with trickster figures who are heroes, jokesters and creators. Coyote and Raven are trickster figures for several Western and Great Basin Native American tribes. Trickster figures can behave in ways that are both good and bad, even heroic. Raven brought the sun and light to the world, but he stole it from the one who kept the world in darkness.

Characters who exhibit human traits of jokesters or heroes are called archetypes. The psychologist Carl Jung created the name *archetype* to refer to people whose behavior, experience and emotions show up in predictable ways in folklore as well as in today's stories. You know many archetypes of our popular culture: the kid who gets bullied but wins in the end, the hooker with a heart of gold, the brilliant but socially clumsy genius, the absentminded professor.

There are also heroic archetypes useful to your creative work: the alchemist who changes one thing to another, the cartographer who defines the path through to the New World, the gardener who takes the seeds from a mature plant and plants them to create a new year's worth of nourishment and beauty. These archetypes are the inner heroes you are going to discover through the journal pages you create in this book.

Your Experience & Your Identity

When you make things, create things, invent techniques, you are not just one person. You are a history of ideas and talents, experiences and dreams. And you are also a mix of inner heroes and your inner critic.

If you listen to your inner critic and stop working, you leave your creativity behind and will never experience the thrill of creating something of your very own, something that not only delights you but also makes meaning for you. Meaning-making brings your life's purpose into focus and helps you understand why you are on earth. You don't want that interrupted constantly.

Paula Kumert, an Argentinean blogger and storyteller with a camera, has a noisy, busy inner critic. I asked her to give me an example of a conversation that stops her creativity through distraction. Here's what she wrote:

Paula [typing]: Hi Quinn!

Inner Critic: *"Dear Quinn," Start with Dear Quinn, it's a formal letter. Don't ruin it from the beginning.*

Paula [thinking before she starts writing]: Dear Quinn, I'm sending you a sample . . .

Inner Critic [interrupting]: *Make sure she knows it's a sample—that you can make it longer if she likes the style, that you can change it round. No, wait, that's "Paperback Writer" by the Beatles and you don't own the copyright. Delete that. What do you mean you can't delete it because you are not writing it yet? What are you waiting for?*

Paula [finally writing]: . . . of my writing about the inner critic.

My inner critic is tricky. She comes to me disguised as the Wise Woman and fools me because she is so sensible when she points out another slightly different/smaller thing to do instead of the big plan. I believe in her words at first. The tasks look logical and all important, but it is not like breaking up the big thing into smaller steps that way. It is adding a completely new path that leads me away along a twisted road, so I spend a lot of time doing other things. Her tone gets more and more urgent and loud as she lists a whole bunch of tasks—each smaller and fur-

ther away from the goal I have to complete before I can do anything else. At that point my work is no longer preparation, it is a stall technique.

Inner Critic [interrupting again]: *"Dialogue," she said. "I love your dialogues with your inner critic," Quinn said. This is not a dialogue, in case you haven't noticed.*

Paula [using her word counter]: She asked for fifty to one hundred words.

Inner Critic: *You're opening her site again? You'll send her metrics askew. She will think she has a stalker. She'll never talk to you again. Ever.*

Paula [about to hit the Send button]

Inner Critic [smacking Paula on the shoulder, hissing]: *She'll take you out of her smart-people list if you forget to add your data so she remembers you.*

* * *

Do you recognize your own inner critic as similar to Paula's? I sure did.

Chasing the inner critic away works but not for very long. Back he comes with more worries and bigger fears. But imagine you ask your inner critic to sit down with your inner heroes and have a discussion about you. Imagine what would happen.

Your inner critic might say, "If you paint this way, it will never sell." And you could answer, "This painting style is meaningful to me," then turn the conversation over to your inner heroes.

Inner Critic: You need to make money.

Inner Hero (the Wise Woman): I need to make meaning. If I've made meaning, I can explain it to others

and allow them to see their own meaning in my painting. Understanding paves the way to selling.

Inner Critic: You'll never sell any of this.

Inner Hero (the Cartographer): If I follow the path of my own creativity, I won't get lost when people disagree with my direction and they suggest a shortcut to completing my work.

Inner Critic: Your biggest competitor is doing the newest fad painting, and she's been invited to teach at prestigious retreats.

Inner Hero (the Acrobat): I feel more balanced when I work in ways that allow me to bounce and soar. That's real for me, it allows me to reach satisfying heights.

Inner Critic: You will fail.

Inner Hero (the Alchemist): Success and failure change meanings all the time. Success is creating the best work I can, real gold, not chasing after the more sparkling pyrite—fool's gold. I'm good at what I do, and I can teach best what I do best. Even if I accidentally head into a dead end, I can back up and have learned something.

Inner Critic: You will never sell any of this work.

Inner Hero (the Wise Woman): You've said that before. Is there anything new?

Inner Critic: You will fail.

Inner Hero (the Cartographer): You've been down that track too often; it just runs off a cliff.

Inner Critic: [silence]

You: I thought so. Now I have work to do.

* * *

Having a conversation with your inner critic is a way for you to get to the heart of your own fears, which often aren't any more than recycled insecurities. Using your inner heroes to talk to the inner critic allows you to be more courageous than you feel and to use strengths you may not be quite sure of.

Your ideas, your values, your courage help you speak clearly to the inner critic. Sometimes you may be a cartographer, mapping your way around his ideas. Sometimes you may be an acrobat, leaping over his drag-you-down ideas. Whatever inner hero you use, you will find them on your side, every time.

Writing About Your Inner Heroes

Metaphor, Meaning & Magic

So how do you write about your inner hero?

Sometimes when we write descriptions, they are dry and lifeless. In the story of Persephone, you could describe her as nature-loving, caring and innocent. You could also describe her as proud, tough and ego-driven. After all, she was the queen of hell. But that doesn't really give you the feel of the power she had over her mother, Demeter.

That story is told in a metaphor: Demeter felt the loss of her daughter so much that the world withered and died into winter. When Demeter and Persephone were together, the world was green and warm (spring and summer). This is a long metaphor, but it makes the story vivid and memorable. Metaphor does that. By substituting one concept for another, a metaphor helps you understand and remember the point of the story.

In this book I'm not going to point out the differences between similes, analogies and metaphors because in this case the difference is not important. Substituting one image for another to describe an emotion or event so you can feel it—well, that's important.

Metaphor also helps you develop subtle colors in your meaning-making. When you choose a metaphor that is meaningful to you, your story will make meaning for you. You will see shifts in your reality more clearly. Your creative work will come into sharper perspective.

The magic of metaphor is that you can have a new and different Aha! moment every time you read it.

In the Persephone story, you might realize that powerful emotions change and rule your world. Or that a job that seemed hateful had some excellent advantages. Or that being dragged to hell does not end your life on earth. That's the magic of metaphor.

Villains & Heroes, Two Sides of One Coin

In every culture, there are heroes and villains. The Greeks and Romans had gods who were both heroic and cruel, depending on their moods. Persephone, the goddess of seasons, was the daughter of Zeus and his mistress Demeter, before Zeus married Hera. Persephone was so beautiful she attracted the attention of her uncle Hades, god of the underworld. Hades persuaded his brother Zeus to allow him to marry Persephone, but rather than drop down on one knee, Hades split the earth open while Persephone was picking flowers and dragged her to hell. Then he made her his queen.

Persephone's mother, Demeter, mourned so intensely that the plants died and the world grew cold. She refused to let the earth come alive again until Hades let Persephone go.

Persephone missed her mother, but she also liked being queen, even if it was of the underworld. A compromise was reached: Persephone would spend part of the year in the underworld (fall and winter) and part of the year with her mother (spring and summer), thus creating the four seasons.

The Greek and Roman gods were kind, wise and generous. They were also petty, mean and spiteful. They used their powers to help and to punish. You are a mix of inner heroes and your inner critic. Getting to know them will be useful in choosing whom to listen to and when.

WORKSHEET: crafting metaphors

Now it's time for you to try coming up with some metaphors of your own. Warm up with some writing exercises. Fill in the blanks with metaphors.

The yellow paint can fell off the top of the ladder, making a

_____ . Example: harvest moon stain on the floor, surrounded by comet splashes up the wall and across the door.

She grabbed her paint brush as if _____ .

The frozen windshield shattered, creating a _____ .

The heat squeezed through the windowpanes, making the room _____ .

You can download more worksheets at www.artistsnetwork.com/innerherocreativeartjournal.

Discover the Magic Already Living in Your Journal

Now you are ready to add a bit of metaphor to your life story!

Open one of your finished journals to a page you love. If you don't have a completed journal, use some of the exercises in this book that you've completed. What wisdom can you find? Did you write down a song lyric or quote you really like? What does it mean to you? What would the same song lyric have meant when you were much younger? How have you changed since then?

Your journal is full of wisdom. Too often, we finish a journal and put it on a shelf and don't look at it again. What a waste of beauty and wisdom! Take those memories off your shelf and let them back into your life. You have a stack of wisdom from all your inner heroes waiting for you.

What's Next? Opening the Door to Your Own Imagination

Each of the hero chapters to follow highlights an inner hero using an art technique and a writing technique to create a freestanding page with art on one side and journaling on the other.

Both techniques are described step-by-step so you can create a page of your own. You can jump off and create your own heroes, experiment with techniques and develop writing inspiration. Your pages will have your creative fingerprints because they are your inner heroes speaking to you. You can make many different pages because your inner hero can help you in many ways.

You share characteristics with your inner hero, but none of the chapters are about drawing inner heroes as people or doing self-portraits. Instead, you are going to create art that reminds you of your strength and allows your inner hero to emerge as a voice to confront your inner critic. These pages will then help you confront your inner critic with strengths from your inner hero.

The resulting loose-leaf journal will be one you reach for over and over again for wisdom and meaning-making.

Notes on the Inner Critic:

"I think that being an artist means being self-evaluative and self-supportive in equal measure. It is difficult to sustain a creative life without both in place. My inner critic is the one who makes me spend the extra afternoon on an illustration before calling it 'finished,' who helps me pick artwork to frame for a show or who makes me get rid of that 'great' brushstroke that's keeping a piece from hanging together.

"I do get creatively bogged down sometimes. When I do, I make small inkblots at home, let them dry, then draw into them on the subway—regular symmetrical inkblots or ink blown into tendrils though a straw (like the accompanying illustration). I take along a stack of them in my bag, along with colored pencils and an acid-free pen. I am transported far beyond the 149 blocks I travel and arrive at my destination with my mind—including the inner critic—refreshed."

—Margaret Peot

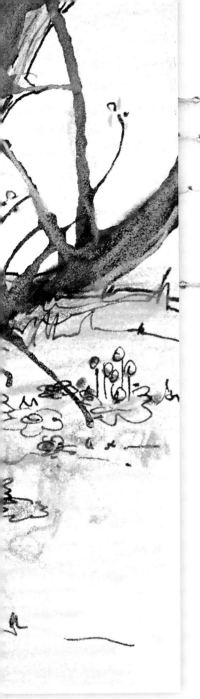

THE SCRIBE & FREEWRITING

Your Scribe is an important inner hero to have. Not only does she write descriptions, instructions and histories, but she also writes poetry, prayers and dreams. The Scribe, like all heroes, has a bit of superhero in her soul. Her ability to choose the words that clarify what you need to do to confront and overcome the destruction of the inner critic is going to make you love her, and it's why you need her in your journal. She helps you learn from your mistakes and keeps you from repeating those mistakes. The Scribe page is not meant to depict your Scribe as a superhero, but rather represent your inner hero Scribe in colors and abstract aspects of your art that make meaning for you and you alone. You can choose to share your meaning with others, but the Scribe helps you understand your own journey.

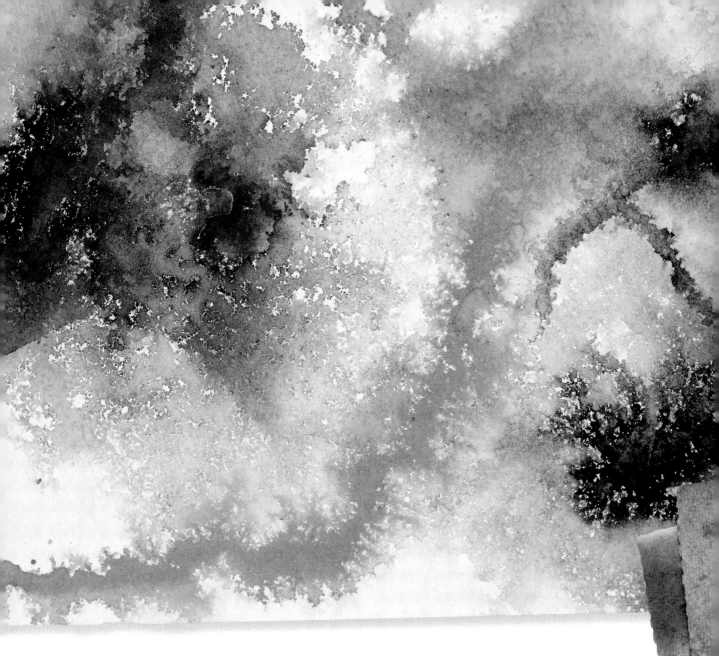

The Scribe's art would be in ink, of course. Ink instead of paint. Ink that becomes illustration or abstract art. Ink that splashes, sprays and sponges. Ink comes in varieties meant for calligraphy pens, fountain pens, dip pens, brushes. Different inks transform paper differently, creating soaking spots of color, shooting across the surface of paper, using water to jump across the page. Ink is a medium of color, texture and flow—all for you to explore.

The Scribe's wisdom would be held in freewriting. Freewriting takes the leash off your imagination and allows the Scribe in you to run around without barriers and forbidden topics. Freewriting lets you free associate, leapfrog over mental blocks and connect one topic to another idea until you have some profound connections on the page, ready to dig into like an archeologist and bring out shards and treasures to assemble into your collection of wisdom from your buried history.

Giving up control is a requirement of all art, and using ink as watercolor gives unexpected results as the inks touch and flow. You can add a background to your page by spraying, sponging or painting inks. Don't limit yourself to inks for backgrounds. Acrylics, sparkling inks and dyes can mix in many ways for surprisingly beautiful accidents.

In each of the art/writing exercises in this book, please feel free to do the writing first or the art first, regardless of the order they appear in the book.

22

Different Inks for Different Uses

Inks vary—some are dyes and soak into fibers, some are pigment and need to be stirred. Inkjet inks contain adhesives that make them stick to paper. Acrylic inks and India inks contain gum arabic or varnish, so they spread across a damp sheet of watercolor paper with unexpected speed and coverage.

Fountain pen inks contain no microscopic particles to clog the pen. They contain dyes, water, a fungicide and a wetter that makes them flow smoothly across paper. Some fade (the washable varieties), while others are lightfast (permanent).

Calligraphy inks vary widely, from dyes to acrylics that contain particles for color or sparkle and to India inks that contain a carrier to make them lightfast and permanent.

Stamp pad re-inkers are dyes that soak into cotton-based papers, which, if they are wet, separate out the component colors. A denim blue re-inker may create a blue spot that separates out into a pink, a gray-blue and a hint of turquoise as it dries on the paper. You can see the results on a paper towel in the image on this page. The pink spot was originally a drop of denim-colored re-inker mixed with distilled water. It separated into blue and green and pink. (The yellow was already on the paper towel.)

Alcohol inks don't give good results on paper but work well on metal, plastic, shiny or hard materials.

Acrylic inks contain pigments including mica or metal flakes, so you should stir or shake them before use. Shaking produces bubbles, stirring does not. Different results from each will give you different color intensities and texture.

You can use any ink with a dip pen (with replaceable nib), dropper or brush. Fountain pens are not made to be used with anything except fountain pen ink. Technical pens (like Rapidographs) can take India ink. Experiment with inexpensive pens until you know how your ink will affect the nib and fluid feed. A bottle of pen cleaner is your friend. Pens are like brushes—they need to be cleaned to avoid buildup of gunk and clogging particles.

No one ink brand is perfect in every respect. Experimenting is necessary and fun. Keep your inks capped when not in use. Water evaporates out of inks, changing the proportion of dye (or particles) to water, which makes a difference in permanence, amount of coverage and how it reacts in a pen.

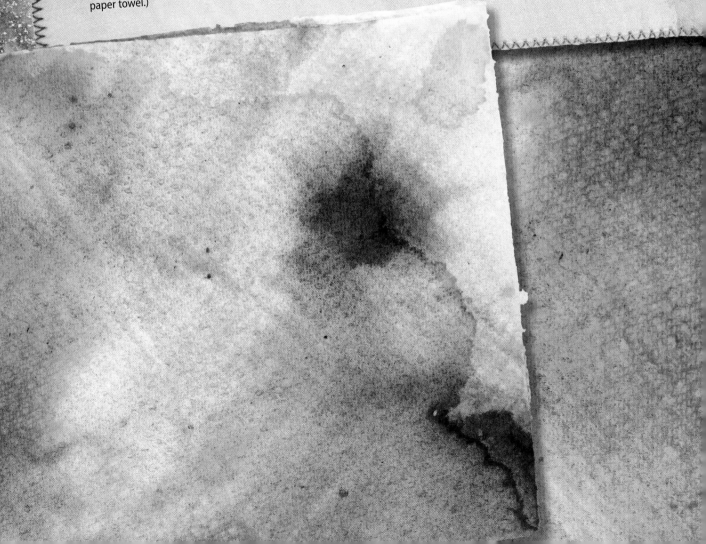

Abstract Ink Art

This technique works best if you leave the background till last. That's right—the background goes last. The abstract ink pattern needs paper that's freshly sprayed with water and without other inks to get in the way of the drip technique.

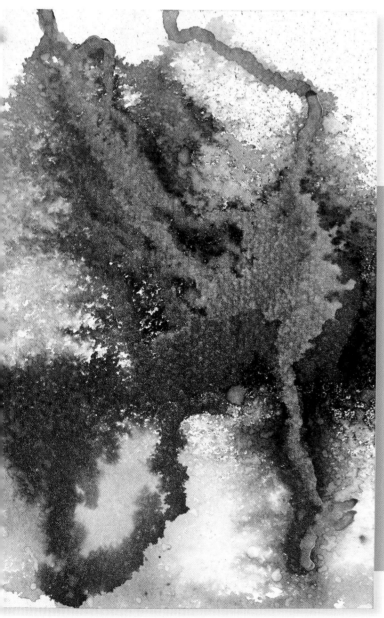

Before You Start:

Permanent ink stains clothing, skin, nails and cuticles. Wear a barrier cream or use gloves if you don't want to scrub your hands for days. Protect yourself with an apron or old clothes. Protect your work surface with parchment or wax paper and have paper towels to wipe up spills.

WHAT YOU NEED

5" x 7" (13cm x 18cm) cold-pressed watercolor pack, 25 sheets (Strathmore Ready-Cut)

parchment paper (to protect surfaces)

medium spray bottle (about 8 oz. [230gms])

distilled water (filtered tap water is fine)

variety of ink (at least 3 colors)

eyedropper or pipette

paper towels

coffee stirrer or straw

watercolor pencils

gel pen with metallic ink

Optional

small, inexpensive brush (kid-size watercolor brush)

hair dryer

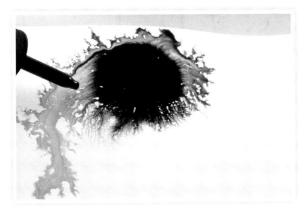

1 Spray both sides of the paper lightly with water so they are covered evenly with droplets. Start with the darkest ink color, and let one drop fall on the paper. The ink will spread over the surface of the water and then sink into the paper.

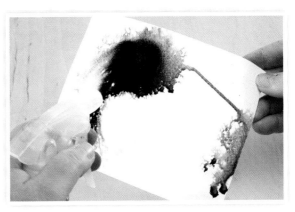

2 Spray the darkest spot of the ink and tilt the paper, allowing the ink to develop "legs" and spread.

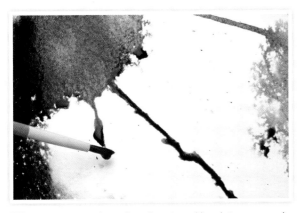

3 To create more legs, dip a fine-tipped brush in water and rub it over the ink, causing the ink to run. Guide the ink from drop to drop, connecting the drops with a trail of ink. Use an inexpensive brush; inks contain varnish that will stiffen the brush over time. Hold the paper over parchment on your work surface to protect it from ink drips.

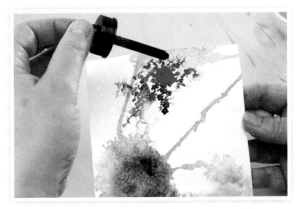

4 To lighten the ink color, blot with a paper towel. To create darker ink designs, lay the page flat to dry or use a hair dryer. Once the paper is completely dry, use water to spray the surface again lightly. Drop a second color (here, Dioxazine Purple) and allow it to spread and run onto new areas of the paper and into the previous color.

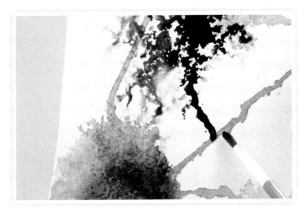

5 Control the overall pattern of the ink by tilting the paper and using a wet brush to guide the direction of the ink from drop to drop. Scrub dark ink spots with a wet brush to create more ink to run. You can create new trails in different directions this way.

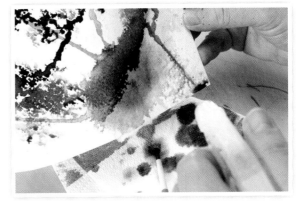

6 If you create a trail you don't want, you can fade or possibly erase it by spraying with a stream of clean water just on that part of the paper and blotting with a paper towel. This must be done while the ink is still wet.

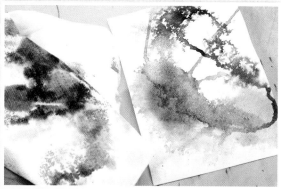

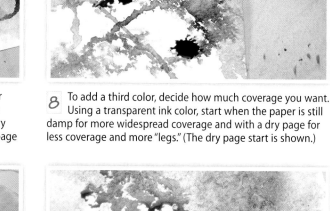

7 To stop the spreading, blot the wet page with a paper towel. Any blotting will lighten the ink. For darker ink markings, lay the page flat and allow to dry naturally or dry with the hair dryer. Do not hold the dryer so close to the page that you blow or spread the ink into a new pattern.

8 To add a third color, decide how much coverage you want. Using a transparent ink color, start when the paper is still damp for more widespread coverage and with a dry page for less coverage and more "legs." (The dry page start is shown.)

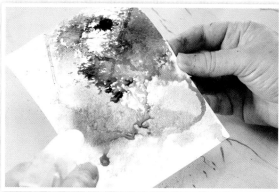

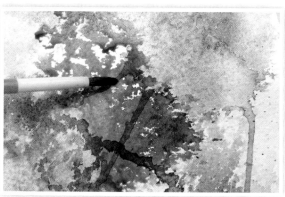

9 Drop a third color of ink onto the paper and spray lightly. Direct the ink's movement to lead the viewer's eye around the page. Use a light touch; previous ink layers will blend if you scrub too much.

10 Use a brush to paint ink carefully on the page. In addition to a brush, use a hollow coffee stirrer or a straw. Place the opening of the straw very close to the drop, and blow in the opposite end. The ink will divide into smaller drops and stretch across the page. This action adds direction and movement to the image. Margaret Peot uses this technique on the tree roots and branches at the start of this chapter.

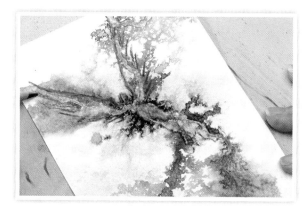

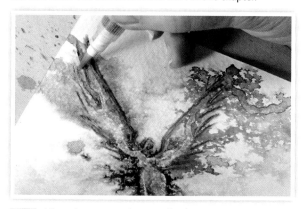

11 Once inking is complete, look at the page from all sides. Sometimes you can see an image emerging from the abstract. Above, after the gold was applied over the heavy spot of Payne's Gray, there is the beginning of an angel with outstretched wings. It was not created intentionally; I simply noticed it when it was complete.

12 Allow the page to dry completely. Using watercolor pencils, begin to add detail that brings out the image— in this case, the angel. Darken the background to raise the light portions. Use a gel pen with metallic inks to complete shapes that allow the eye to see the image you want.

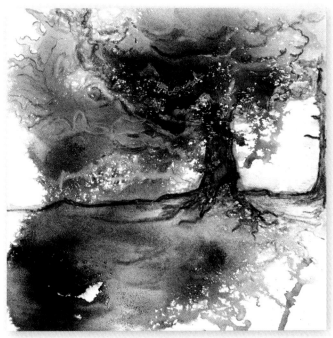

A partial image of a woman's face behind the tree appeared in an ink-flow experiment. The lip and eye were half formed. I noticed them while photographing the piece, then completed the face with contrasting watercolor pencil. You will find hidden images more easily by looking at photographs or scans of your work.

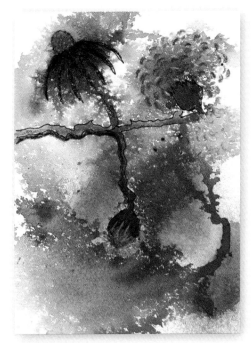

What you see may depend on the season, a conversation or an experience. I noticed the beginning of the abstract flowers after looking at tapestry fabric.

Use a good quality paper towel or restaurant-grade paper napkin for blotting paper for your ink-flow experiments. These dyed papers can be used in collages or stitching to add color or texture.

Tips for Using Shimmer Inks

- To use shimmer inks on a background, buy premixed mica sprays. They are already in bottles that don't clog easily. If you use your own bottles, they may clog.

- Shimmer background adds light and texture. Protecting the main ink pattern allows the background to blend nicely without hard edges.

- To blend spray ink colors, you can mix them in one bottle. But you can also mist the paper with water, then spray both inks one at a time using sweeping motions. The lightest ink goes down first, then the darker ink. The blend won't be even or look like brushstrokes, but the colors will drift together for a blended effect.

- When you are finished using spray bottles, use the water bottle to spritz the nozzle of each bottle, then cover with a damp paper towel for half a minute or so. This removes ink and mica particles that would dry and clog the nozzle.

- Keep the paper towels you use to wipe up ink. They often develop interesting patterns and can be used in fabric collages. (We will explore about fabric more in the Alchemist chapter.)

The Scribe's Writing Technique: Freewriting

The writing on the other side of your page is the wisdom of your hero, Scribe, told in your voice. You can choose to do the writing side first or after the art side is finished.

You start by writing in a journal or notebook, then distilling what you wrote into a sentence or two. That's the sentence you put on the back of the artwork.

But first you have to create the words. Like the art side, the words on the page are not your idea of what a Scribe would say, but rather wisdom that emerges from your own writing.

Before You Start:

Your raw material will be your own writing, done in a journal or on a sample sheet of paper. It's best to use a comfortable pen—ballpoint, fountain pen or any writing instrument that you can use to write quickly and steadily.

Write by hand. Writing in a journal or on a piece of paper creates a totally different feeling than writing on a computer. Your writing slows down, and you engage both parts of your brain: the left in the mechanical process of writing and the right in creative thought. The part of your brain that distracts you, thinks of too many topics at the same time, wonders if it's time to do the laundry or drive the car pool, is kept quiet by the act of writing.

When you want to tap into the wisdom of your inner heroes, it's best to write first and then sift through the words for the strength and power of your inner hero. You can write several sample pages, but you will need only a sentence or phrase to remind you of the wisdom and meaning.

Find a quiet place where you can write without being disturbed. Turn off the phone and TV.

WHAT YOU NEED

quiet place

journal or notebook

pen (comfortable, reliable and that you can write quickly with)

timer

box of words (see sidebar), list of favorite words or book you enjoy

Box of Words

Keep a list of words you like—words you read, words that have meaning to you from events in your life. Cut an index card in half, the long way. Cut each of the long pieces into thirds, so you have six pieces of index card.

On each piece write one of the words from your list that you like. Keep the words in a decorated box. Keep a supply of index cards in books you read or in the cover of your e-reader. Over time you will collect a lot of words. These make wonderful words for freewriting.

Until you have enough words in your box, you can use a favorite book as a prompt to supply words. Open the book at a random page and, without looking, put your finger someplace on either the left or right page. Use the verb or noun closest to your finger as your starting word (no sense using words like *the, about,* or *for.*) You now have a prompt to write with!

After completing the freewriting and looking at the one or two sentences you distilled your thoughts into, ask your inner Scribe to help you answer the following questions. Take notes on a new page in your journal or, if you leave big margins, in the margins of your writing, using a different color ink.

- What did I think this was going to be about?
- What turned up that surprised, interested or delighted me?
- Is there a theme that's familiar to me (something that comes up frequently in my stories about myself)?
- What new sentence could I write to summarize the best ideas about this writing?
- What one sentence would my inner Scribe want me to remember? Write down an action, an idea or a supportive phrase that helps you know yourself better.

cut lines

1. Once you know your word, write it on the top of your journal or notebook page.

2. Set the timer for three minutes.

3. Begin writing anything you can think of about the word—free-associate without thinking. Just write. You are not writing a story; you are writing down ideas or memories. Let the ideas jump around. Don't lift your pen from the paper, don't edit, don't go back and read what you wrote. Just keep writing. When the three minutes are up, stop. Shut the notebook and don't review what you've written for a few hours.

4. When you return to look at the writing, think of your Scribe, and the wisdom she might have for you. Read the pages you wrote and underline any phrases or sentences you find important. Copy these on a fresh page and spend a few minutes thinking of the strength in the words. Distill one or two sentences you would like to remember.

find fun bonus content from this book at www.artistsnetwork.com/innerherocreativeartjournal.

29

It may take several tries of freewriting for you to feel comfortable with this process. Be patient with yourself. Try it several times, giving yourself some space and time to practice.

The sentences you write will become the words your inner hero uses to confront your inner critic.

Here's a sample of freewriting complete with jumping ideas and a lack of a clear timeline. Freewriting doesn't focus on getting it right, just getting it down on paper.

Why freewriting works: The writing jumps from topic to topic, along with your mind. By not editing, you let your mind travel down paths along which you might stop if you were journaling. By not going back and reading what you wrote, you don't fix your writing to one channel you think it should go in. When I wrote it, I thought it would be about eating and sharing family meals. But that's not what showed up. In freewriting, capture the mix of thoughts you have just as they come up—unorganized and rambling.

Kitchen Table

Everything happened at our kitchen table. We ate all our meals there, but we also did our homework, sewed, drew, wrote letters, kneaded bread and stirred cookies, and worked on school projects at that table. We each had our place at the table and never moved anywhere else for meals—that was considered someone else's place. The table was wood and had leaves to put in it for celebrations. It became scratched from use, and my father covered the surface with Formica, but then the leaves didn't fit. My father also finished the edges with stainless steel.

Our places for homework were different than our places for meals, since the parents didn't have homework to do, although my mother supervised homework. We had to do it all in fountain pen ink, and we all became experts with ink eradicator—bleach in a bottle with a glass rod. You touched the tip of the dipped-in-ink-eradicator rod to the written word and it disappeared. You blew on it till it dried, then wrote over it. It had to be dry, or the ink would feather and bleed, and the whole page would have to be copied over.

The table had a tablecloth on it at all times. There was one for meals and a "day cloth" to keep the table covered and pretty during the day. During homework hours we worked on the smooth, dark wood surface, always with a Life magazine under our work so the table wouldn't get scratched. Even when it was scarred, we kept doing that.

The table was pretty beat by the time I was 8 or 10, but it was the center of the house. Serious conversations were reserved for the kitchen table. Guests sat in the living room, but when it came to discussing school, problems and the future, the conversation moved to the table. Birthdays, good news and bad news were delivered at that table. My mother would read letters from relatives overseas to us at the table, placing the light blue, fragile tissue airmail pages with the strong, sharp writing carefully face down on the table as she completed each page. My brothers had known the hands that wrote those letters, knew their faces. I had not. But I knew their lives and thoughts vividly.

Looking for a theme: The table was used for many events. It was the center of our home's activity. But what I remember most clearly was not the meals or the domestic work and chores, but reading and writing at the table. I hadn't thought of that in years. But one of my best memories of my childhood is that I spent a lot of time reading and, later, writing.

Here is the Scribe's focus of that note, the idea that seems to be important: Mistakes can be fixed, people

known, the heart expressed or expanded, all with words called forth on a sheet of paper.

This is the wisdom that I took from the freewriting: *Writing frees you, allows you to rise above the daily dust and see clearly. What is the real issue you need to write about?*

As you can see, that is the sentence I wrote on the back of the journal page.

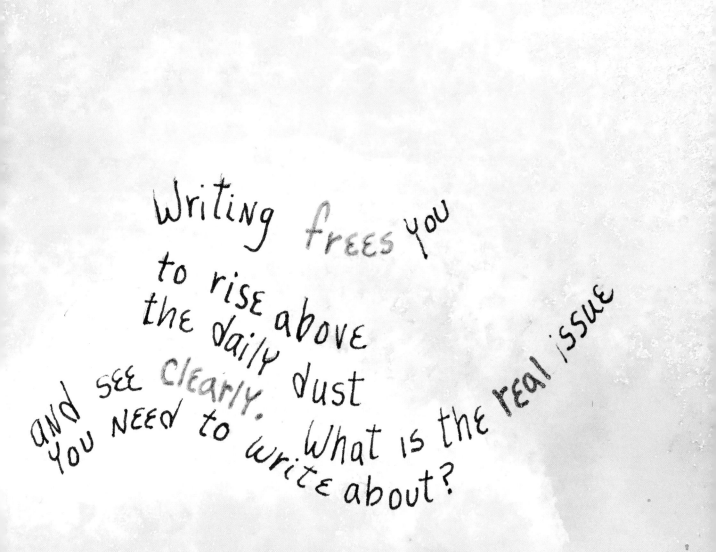

Creating a Background for the Scribe Page's Journaling Side

Now that you have done the journal writing and distilled the sentence, you are ready to create the background on the writing side of the loose-leaf page. You'll want the pages to be unified, front to back, so the background for the writing should look similar to the work you did on the front. If you prefer abstract designs, unifying the front and back designs will allow the page to carry the inner hero's message more strongly.

1 Mix ink into water in a 2:1 ratio (e.g., two teaspoons ink into one teaspoon water) in the small spray bottle. Test on a scrap paper. Adjust the color intensity until you are satisfied. Set aside. Place a paper towel on a protected surface. Place your page, design side down, on the paper towel. Crumple a small piece of parchment or wax paper, and place it in the center of the back of the Scribe page. The crumpled paper should not extend beyond the page's edge. Spray ink onto the back, allowing the parchment to shield part of the page.

WHAT YOU NEED

ink (use color from design side)

distilled water (filtered tap water is fine)

small spray bottle like a Mini Mister

paper towels

parchment paper or wax paper

larger spray bottle

spray bottle of glitter ink, if desired

gel or glitter pen

soft pencil, 2B

eraser

Faber-Castell Pitt pen or Micron pen, black

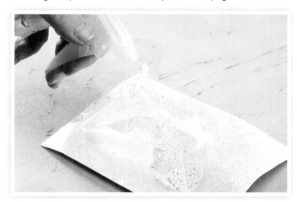

2 The paper towel will soak up the ink that runs off the page. Before the ink dries, spray water lightly from a different direction. Do not turn the card over. This directional spray will create interesting color blends. Spray more ink, using a different mix ratio or glitter ink, if desired. (You don't want an even ink color.) Lift off the parchment paper and discard.

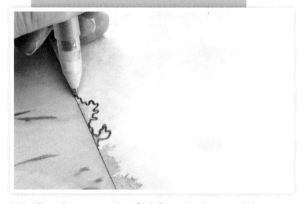

3 Allow the page to dry. If ink from the design side has crept onto the writing side, you're in luck. Using a gel or a glitter pen, outline the ink along the edges in a contrasting color. This calls attention to it and looks like a deliberate, abstract design.

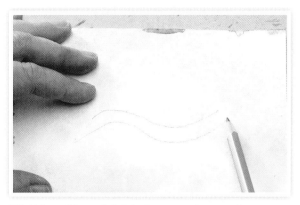

4 | If your ink design is too small, dip a fine-point brush in ink and add some squiggles along the edges. You can also unify colors, hide air bubbles that left white spots or blend from one color to another. Don't overdo this part, but do not be afraid to add edging detail.

5 | Using a 2B pencil, lightly draw curved or wavy lines across the page, focusing on the blank spot left without ink by the parchment. You will write your chosen sentence from the freewriting exercise in this spot. Draw more lines than you will need. It's easier to erase than to add.

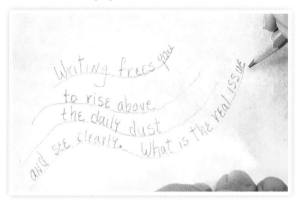

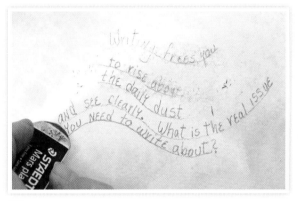

6 | Choose the sentence you have distilled from freewriting. Print or write it in 2B pencil along the wavy lines to make sure it fits in the size you want. Read it over to make sure it looks just the way you want it.

7 | Using an eraser, lighten the writing so you can just make it out. Erase extra lines, too. If you wait till later, it may drag the ink or wear it unevenly. If your hands are inky, use a big, clean paintbrush to wipe away eraser crumbs. They can soak up ink and track it on your paper.

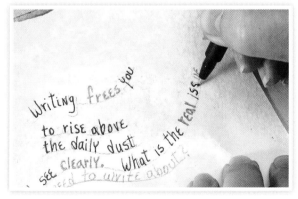

8 | Write over the important words in gel pen or bright ink, then write in the rest of the words using a black pen. Fix any small spacing problems as you go along. You don't need to be a calligrapher; your handwriting is uniquely yours. The advantage of loose journal pages is that you can turn them at any angle and never deal with a gutter. And you can work on more than one page at a time.

9 | Allow the page to dry. (Gel pen dries slowly, give it enough time.) Then carefully erase any stray pencil marks and lines.

Other Backgrounds for the Scribe Page

Some more suggestions for creating Scribe-page backgrounds:

• Continue the ink theme by spraying and blotting inks on the background. The wetter the background, the more the colors blend.

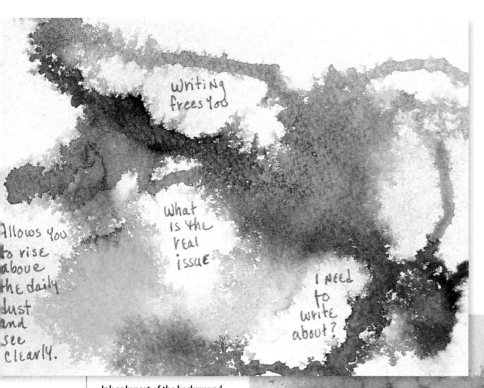

writing frees you

What is the real issue

I need to write about?

Allows you to rise above the daily dust and see clearly.

• Mix ink with water and paint on the back. Before the ink dries, take kosher salt (the grains are bigger than regular salt), and sprinkle it over the wet paint. Let it dry completely before brushing off the salt, then add the words.

• Ink only part of the background. Let the ink dry. Spray a very pale shade over most of the page, trying not to cover the page, just letting the colors blend. Write only in the blank spaces.

• Dilute ink by adding about three times as much water as ink. Dip a no. 8 (thicker) brush and coat a dry page evenly, allowing it to dry but not completely. The page will feel cool, but no water will be visible. Rinse out the brush thoroughly, then fill it with clean water. Flick the water randomly on the not-quite-dry page. The page will develop interesting spots, some of which may separate ink colors. (This depends on the type of ink.) Let it dry, then begin writing. Or connect the splatter dots into writing areas before writing.

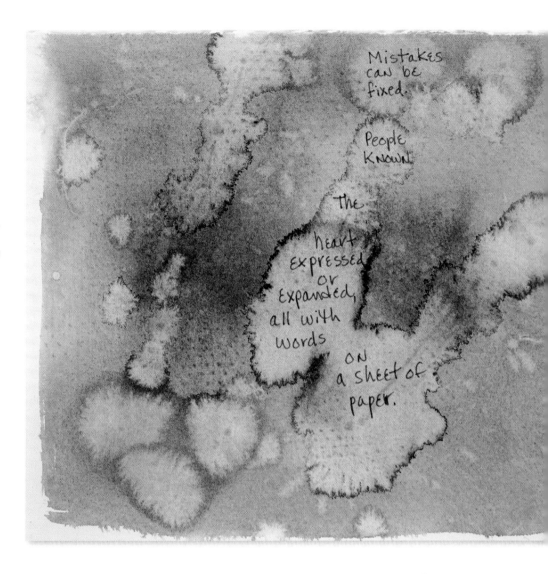

Because these pages are loose and not in a book, you can match the colors to the front or choose a different colorway.

Printing in your own handwriting gives you the strength of your convictions and reminds you of your link to your inner Scribe. Your handwriting doesn't have to be beautiful. These pages are for you, so create them in ways you love. Write in gel inks or markers. Use different colors for different words, and write the important words larger than others.

If you prefer type, you can print out your final draft in a typeface and color you like. Cut or tear out the words and glue them on the prepared background. You can also stamp your message using letter stamps.

The most important part is knowing that you are your own inner hero, reminding you of your own strength.

find fun bonus content from this book at www.artistsnetwork.com/innerherocreativeartjournal.

35

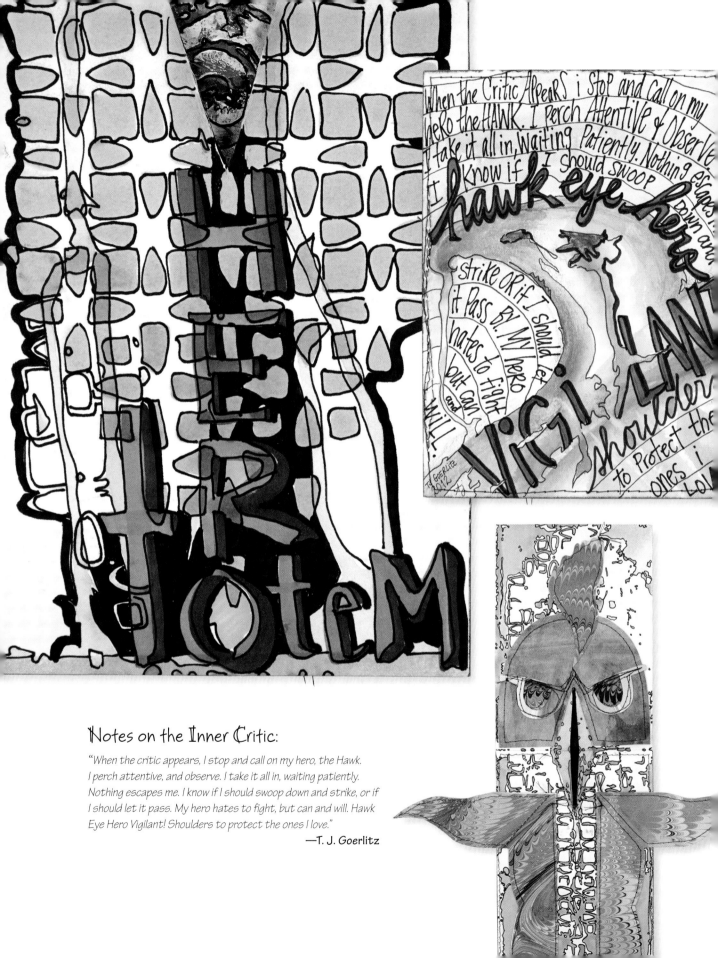

Notes on the Inner Critic:

"When the critic appears, I stop and call on my hero, the Hawk. I perch attentive, and observe. I take it all in, waiting patiently. Nothing escapes me. I know if I should swoop down and strike, or if I should let it pass. My hero hates to fight, but can and will. Hawk Eye Hero Vigilant! Shoulders to protect the ones I love."

—T. J. Goerlitz

THE TAROT READER & TWIN & TRANSFORM

The Tarot Reader has gifts that are magical and useful. She sees the deeper meaning of individual pages as well as an overview of all the pages and the meaning they might hold for your creativity.

The Tarot Reader loves to consider hidden meanings that aren't always obvious when you first see them. She compares ideas and images that are different and transforms them to *Aha!* moments and deeper understanding of your skills. You will have your own idea of how your inner Tarot Reader appears—and it's not necessary to ever have used a tarot deck.

In this section, you'll meet a new inner hero, your Tarot Reader. She is represented by the art technique of paper mosaic—a combination of collage and paper. The writing technique is Twin/Transform, a way to discover which of your strengths are equal to the Tarot Reader's and which strengths can be transformed into a powerful push against the inner critic.

Both techniques are described step-by-step so you can create your own idea of the Tarot Reader in your life. Once you've seen the techniques, you'll use your favorite photographs or colors to create your inner hero Tarot Reader. She brings you secret wisdom and understanding. Your page will have your creative fingerprints because your inner heroes speak to you and inspire you to confront your inner critic.

You are not going to draw an image of a tarot reader or even one of the major arcana. Instead, you are going to invent your own inner hero and create art that reminds you of how you and your Tarot Reader are twins and how you can transform that power to confront your inner critic. T. J. Goerlitz, whose art appears at the start of this chapter, kept seeing hawks in the sky when she had a problem to face. She created a hawk totem figure for her inner hero. She handled the idea of mosaic by combining different papers for different parts of the piece, including a beak that opens and closes when the card opens.

You don't have to know how to draw or paint. What you know about art journaling right now is enough.

You can make many pages for each inner hero, giving you a stack of loose-leaf journal pages to reach for over and over again for wisdom and meaning-making.

Call on the Tarot Reader when you are seeing too many details and not the whole picture. If you are seeing too many trees and don't think you are in a forest, your inner Tarot Reader can help you see the overview of the whole. Use the writing exercise to see what strengths you and your inner hero share and how you can use her wisdom to transform your confrontations with your inner critic.

Photographs & Color Blocks

Because the Tarot Reader uses paper, for the art side of these cards you will cut up several photographs that are dissimilar—people in one and landscape in another, for example—and then combine them to create a combination of people and places that are significant. The key to making this page powerful is to use photographs that have deep meaning for you. You can use contrasting images or images that complement each other in your memory.

You can also use color blocks—squares from your discard pile of paintings, squares from paint swatches, even squares of fabric you may have. The squares can be unifying or distracting, depending on your mood.

Twin & Transform

The writing technique helps you twin or mirror your inner hero's powers and transform them. You'll use a chart to track your strengths that twin your inner hero's. You'll discover that some of your strengths may first look like weaknesses but are hidden powers to confront your inner critic. In another technique you'll see how to transform small gains into big ones through writing practice.

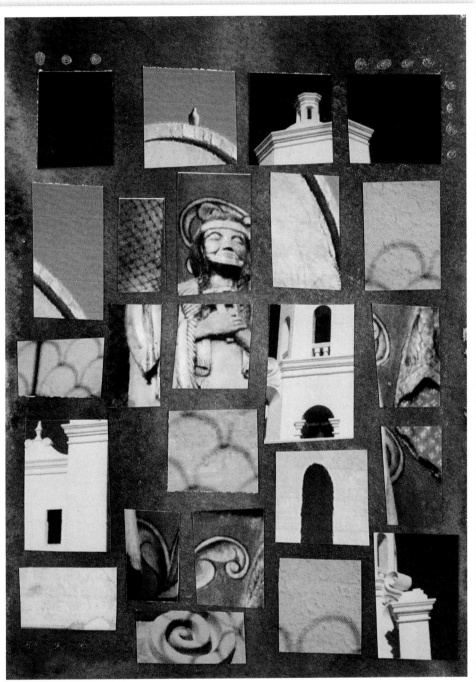

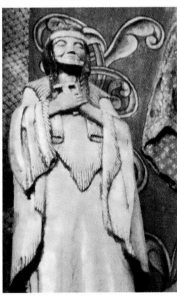

In my example, I used four photographs of Mission San Xavier del Bac, south of Tucson, Arizona: one of the outside of the mission; one of a wood carving of Native American and saint, Kateri Tekakwitha; and one of a separate adobe building with a shadow of a wire fence on the adobe building.

Photo Mosaic

Before You Start:

The first step is choosing your photographs. It's helpful if each is at least 4" x 6" (10cm x 15cm). The prints can be on different surfaces—glossy or matte, paper or photographic paper. Coated papers (glossy surface) will make other colors more saturated and will advance; matte papers will make colors look more subtle and will recede into the page.

Orientation (horizontal or vertical) is not important. There can be one of each or two of the same.

The colors in the photos should be compatible. Clouds in a blue sky work well with botanicals of close-up green leaves or yellow flowers. In addition, select photos with two different subjects—landscapes, botanicals, people, food, birds, pets, houses, clouds.

Finally, the amount of detail should vary. For example, a street scene full of people and a landscape photograph that contains people and flowers, when put together, would have too much going on. Similarly, a close-up of a leaf with little texture and a shot of a blue sky with no clouds would not add up to enough visual interest, so select one photo that is more detailed and one that is less detailed.

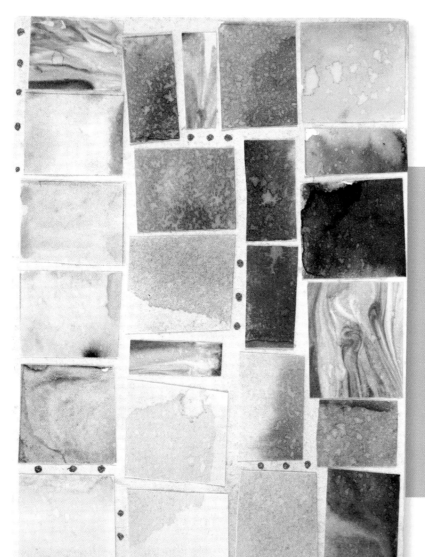

WHAT YOU NEED

photographs, 2 or 3, at least 4" x 6" (10cm x 15cm), compatible colors, two different subjects

paper cutter or craft knife and straightedge

prepainted 5" x 7" (13cm x 18cm) 140-lb. (300gsm) cold-pressed watercolor paper (Strathmore Ready Cuts)

glue (PVA) or glue stick (if that works for you)

watercolor pencils or gel pens

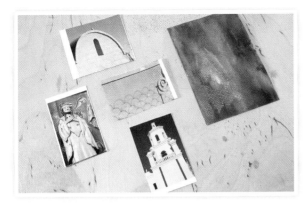

1 Choose two to four photographs; orientation (horizontal or vertical) is not important. I used three photographs of Mission San Xavier del Bac—one of the outside of the mission, one inside (carved-wood statue) and one of an adobe side chapel with a shadow of a wire fence. Prepare an additional page with a background color that coordinates with the photos.

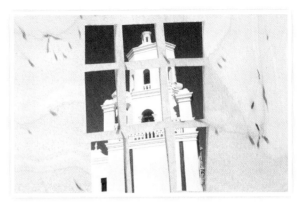

2 Trim white edges from the photos. Cut each photo into three columns and three rows—nine pieces. The pieces do not have to be exactly the same size, so leave identifiable portions (like faces) in one piece. After cutting, reassemble the pieces so you know how the pieces fit together originally. (This will save you time later.)

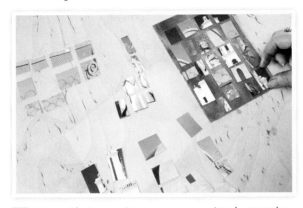

3 Arrange the image pieces on your prepainted watercolor paper (without glue). Use pieces predominantly from one image with a few pieces from each of the others. This allows you to understand the whole image and relationship of the pieces. Leave visible spaces between the pieces. Your finished shape doesn't have to be a perfect rectangle.

4 Once you have decided on the arrangement, glue down the squares with a PVA glue or a glue stick. Putting a small dot of glue in the corners of each piece will give you a few seconds to correct any placement mistakes. Avoid sliding the pieces around; glue smears will show when dry.

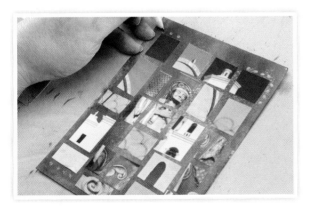

5 When the image has dried, add dots or triangles at the outside edges with watercolor pencils. You can also call attention to specific squares by putting dots or other decorative elements between squares with a gel pen.

find fun bonus content from this book at www.artistsnetwork.com/innerherocreativeartjournal.

41

Variation: Color Block Mosaics

Interesting mosaics can be made with color and texture alone. If you prefer abstract work, you can use pieces cut from your discarded paintings or from paint swatches.

Abstracts are interesting if the color goes from light to dark. Our brain interprets the "right way" to be light colors at the top of the page and dark at the bottom.

Tips on a Colorful Background

• Paint the entire front of the page with a watercolor wash in a neutral: beige, gray, walnut ink or a metallic like gold or bronze.

• Choose the dominant color from one of the photographs and create a painted background using that color.

• Vary the background by making it a bold color such as Payne's Gray or Carbazole Violet, Cascade Green or even Quinacridone Gold.

• Use a wash of two colors, but be careful not to divide the page in half with color; that will jar your eye. Do about one-third in one color (side to side or top to bottom) and two-thirds in another color.

• Using watercolor pencils, draw light diagonal lines across the entire page, about ⅛" (3mm) apart. Use one or two closely related colors. Using a damp sponge, blend the colors so some of the lines are visible and some blend into one color.

• Choose a dark and a light shade of a color used in both photos. Using inks or watercolors, mix water and color so you can dip a toothbrush into the color. Dip the toothbrush, shake off the excess, and using a toothpick or plastic knife, draw it from the front to the back of the bristles while the toothbrush is facing the paper. This will create a spatter of droplets. Repeat with the other color until the page is covered with a mix of light and dark drops.

More Ideas for Paper Mosaics

- For more contrast, use some paint samples mixed with printed papers; sheet music, old letters or ledger pages make interesting contrast.

- From the writing exercise to follow, use words that you have in common with the Tarot Reader and print them on some of the squares. If you don't want to write on the squares, write the words around the outside of the mosaic or between the pieces if you have left larger spaces.

- Create your own code, or use alphabets or symbols on the mosaic for an exotic, secret-filled look.

- Vary the spacing between the mosaic pieces. The farther apart they are, the harder it is to see the entire piece as unified. This can be an interesting reminder if you often have trouble seeing the big picture.

- Try outlining each mosaic piece with a colored pencil or pen. Use the same color, or try two different colors.

- Instead of squares or rectangles, cut triangles. They fit together very differently.

- Try using a hole punch and creating circles. They are hard to place close together, so the effect will be startling—more like polka dots than a mosaic.

find fun bonus content from this book at www.artistsnetwork.com/innerherocreativeartjournal.

43

The Tarot Reader's Writing Technique: Twin & Transform

Your inner hero the Tarot Reader has the gift of discernment—to see events and projects from different perspectives. It's easy to fall into a rut by solving creative design or writing problems the same way, time after time. Eventually the inner critic shows up and starts to complain. "Are you going to do that forever? Can't you come up with a better way of saying/showing that?" What follows is often a losing battle: Instead of working through a problem, you give up and move on to another creative project.

Working through your creative problems is a struggle best done with a choice of creative solutions because it's easier to see the pros and cons of each idea. Often we don't do that. We do what's fast or what worked last time. It's natural, particularly if you sell your work and do production work making many similar pieces to sell, using the same materials and processes.

As a tarot reader pays attention to both an individual card's meaning as well as the meaning in the whole story of your life, your inner Tarot Reader can see the fine thread of meaning-making you have been stitching through your work, and see where it vanished and your work became drudgery.

When the inner critic shows up to tell you that you are a drudge, it's easy to believe it. You are doing the same thing over and over and have forgotten the purpose, the meaning-making aspect of your art. You don't *find* meaning in life, you *make* meaning through art, through the way you make decisions, through what you choose to bring into your heart, your studio and your art. And when we are working without meaning, the joy and fire goes out of our creativity.

Meaning-making is what inspiration brings to you. The inner hero Tarot Reader sees the big picture and can help you understand where you are in the big picture of the creative process.

Twin of the Tarot Reader

How are you and the Tarot Reader alike? Fill in the chart that follows and see what you have in common. (That's the *twin* part.) The first one is filled in to get you started, along with a few more characteristics to get you going on what you have in common. Complete this chart by thinking about your inner hero and what you have in common before you go on to the next exercise.

What Good Is the Tarot Reader?

- She can offer practical advice for shortcuts, helping you find a new way to do the same thing.
- She can also see the overall use of the project you are working on now and relate it to your whole creative process.
- Tarot Reader knows that an upside-down card represents a different aspect of meaning.
- Tarot Reader signals that events are not always to be taken at face value.

WORKSHEET: twin of the tarot reader

what tarot reader is	what tarot reader says	what you feel about it
Visionary (sees big picture)	This is just the first step; the more you practice, the better it gets.	OK, the first journal page doesn't have to be perfect.
Brave (speaks truth, even if difficult)		
Can see good parts of difficult events		

You can download more worksheets at www.artistsnetwork.com/innerherocreativeartjournal.

45

Getting to the Transform Part

You will find it much easier to believe what someone says in a general sort of way than to believe it about your own life and self. For example (using a quote from the previous chart), if you heard someone say, "This is just the first step; the more you practice, the better it gets," you'd probably nod your head and say, "Well, sure." But if you are asked to be patient with yourself and to practice, what seemed clear before becomes hard for you. The inner critic steps up and starts telling you why you can't do it, or how you are not smart enough, and that someone will take your idea while you are practicing and create a class you should be teaching.

Now is a good time to reach for your journal. Take a look at the chart you just filled in. You've filled in the column on what you feel about your inner hero's comments. The next step is to write down what you can do about your inner hero's comments to move the *feeling* into *action*.

So if your feeling is "My first journal page doesn't have to be perfect," what's an action you can take to make that true for you? Here are some suggestions:

- Make a sample first page (not in your journal) to try out an idea.
- Try some ideas in your journal page, and label them "try-outs."
- Do the page in the book, and label the parts you don't like with suggestions for next time so the pieces you feel are mistakes can be inspiration for next time.
- Get together with a supportive friend so you can both work without pressure.

Write down all the great ideas you have and, using your favorite color, circle the easiest one for you to do. Then circle the one that appeals to you (but may not be easy) with a different color. Write both of these on the back of your inner hero Tarot Reader page.

When you feel your inner critic is the one in charge of your artwork, call on the Tarot Reader to help you out. Instead of listening to the inner critic, listen to the Tarot Reader who sees the whole and the parts together.

Your inner Tarot Reader says, "I started this artwork to _____." [Fill in your reason.] Every reason is OK here, from "I liked the color" to "I wanted to play" to "I was so upset, it calmed me." We turn to art because we know what we need—play, concentration, expanding our skills. The inner critic shows up when we doubt the benefits and concentrate only on the result.

When you remember the real reason you started, it's easier to continue in the right direction. That's the purpose of the Tarot Reader: to help you see what is happening in the whole of your life and how that whole is reflected not only in your artwork but also in your meaning-making. You will call on the Tarot Reader as an inner hero often to show you the value of your work in relationship to your creative growth.

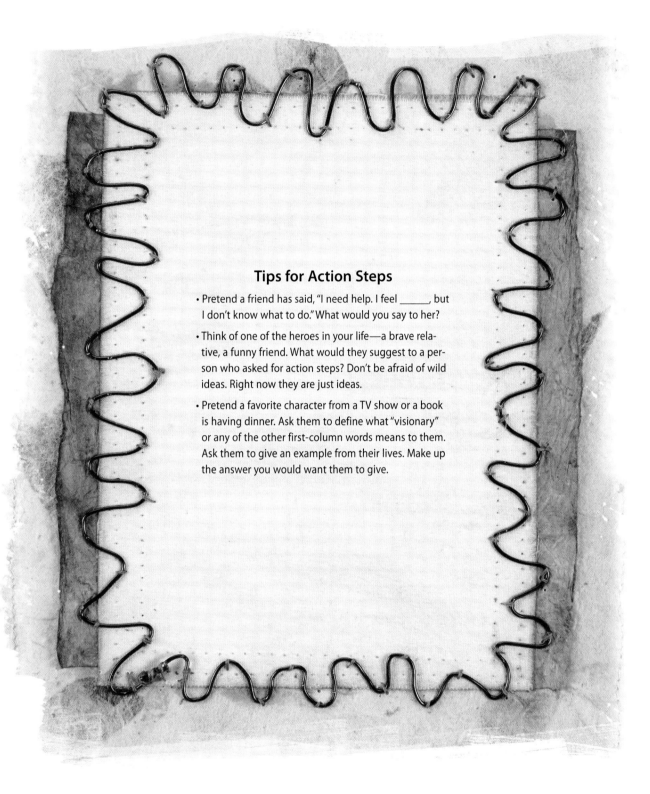

Tips for Action Steps

- Pretend a friend has said, "I need help. I feel _____, but I don't know what to do." What would you say to her?

- Think of one of the heroes in your life—a brave relative, a funny friend. What would they suggest to a person who asked for action steps? Don't be afraid of wild ideas. Right now they are just ideas.

- Pretend a favorite character from a TV show or a book is having dinner. Ask them to define what "visionary" or any of the other first-column words means to them. Ask them to give an example from their lives. Make up the answer you would want them to give.

Creating a Background for the Tarot Reader Page's Journaling Side

Because the front of the Tarot Reader's page is a mosaic, you can carry that theme to the back (journaling side) of the page by creating individual spaces in which to write. These spaces do not have to be close together, nor do they have to be the same size. You are no longer depending on an image for recognition of the whole, but for recognition of your strengths.

WHAT YOU NEED

completed Photo Mosaic Tarot Reader card (from the first art exercise in this chapter)

spray bottle of water

spray ink

paper towel

metallic or pearlescent acrylic inks with dropper

You can outline the border of these lines or boxes with a watercolor pencil to give them more definition.

Other Ideas for the Writing Side of the Tarot Reader Page

• Paint the back of the page with watercolor or acrylic paint. Paint pieces of paper in a coordinating color. Cut out squares big enough to hold a word or two on the cut-outs, write on them and then glue them to the back of the mosaic page. (You are writing on the cut-outs first, so if you make a mistake, you can correct just the one piece. You know how to move around your inner critic!)

• Paint the background a pale shade, make the pieces you are going to write on a dark color, and write on them with metallic, neon or white gel pens.

• Paint the back of the page with one color, then draw spaces for writing—different shapes for different ideas. Color the edges of the spaces in bright colors (use dots or stars) and then write in them with colored inks.

• If color distracts you, you can do the entire back in black and white, drawing areas for writing in crisp black lines, using a ruling pen (calligraphers use these), a broad marker or rub-ons.

• Create the areas you are going to write in using washi tape in different colors.

• If you have a sewing machine, stitch some geometric figures on a page of colored stock, cut them out using decorative scissors, write on them and glue them to the back of the page.

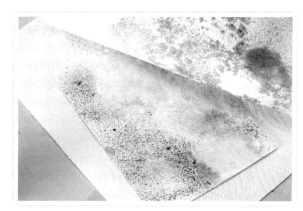

1 Spray the back of the photo mosaic card lightly with water. You should see individual drops rather than a wet slick. Spray ink you have mixed yourself (three parts water, one part ink) into the water you sprayed. If you prefer a more formal look, use a broad brush to paint the ink and water evenly over the back of the card.

2 Spray a paper towel lightly with water, and then press the damp paper towel over the back of the card to lift some of the ink. The results should be light enough for you to write on.

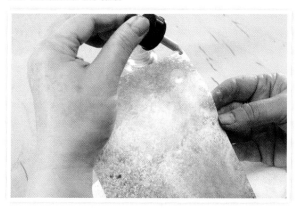

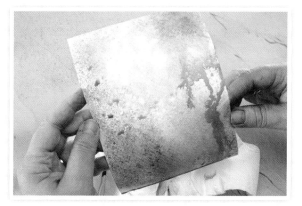

3 Using a metallic or pearlescent ink, create a rustic grid—a series of uneven spaces to write in. To do this, begin by dropping acrylic ink in the upper-right corner of the page.

4 Let the ink run down the page to form vertical trails. Reapply ink to add more trails. Tilt the paper to form horizontal borders around spaces. The sizes should be varied but large enough to write in.

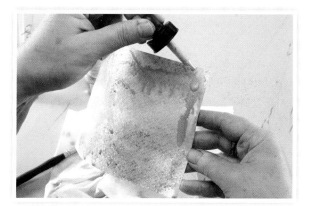

5 If you create a large area of ink, add water and immediately turn the page horizontally to create several trails that run across the page. Use the brush-and-ink technique from Abstract Ink Art (Scribe chapter) to direct and manage trails to create spaces to write in. It should not be even and perfect. You can draw arrows to show the sequencing of your writing.

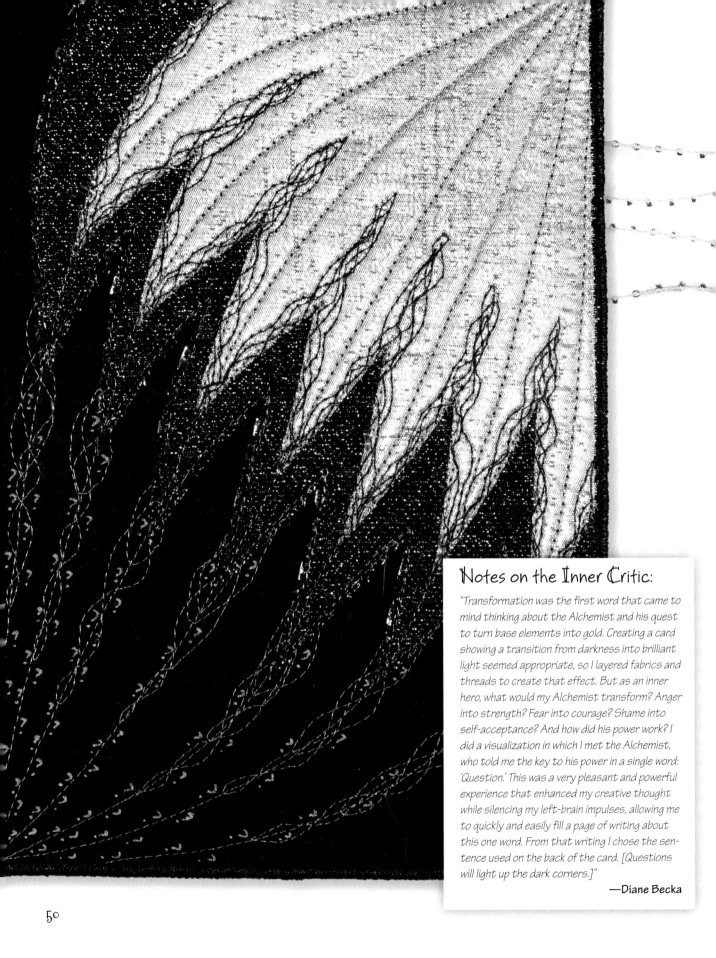

Notes on the Inner Critic:

"Transformation was the first word that came to mind thinking about the Alchemist and his quest to turn base elements into gold. Creating a card showing a transition from darkness into brilliant light seemed appropriate, so I layered fabrics and threads to create that effect. But as an inner hero, what would my Alchemist transform? Anger into strength? Fear into courage? Shame into self-acceptance? And how did his power work? I did a visualization in which I met the Alchemist, who told me the key to his power in a single word: 'Question.' This was a very pleasant and powerful experience that enhanced my creative thought while silencing my left-brain impulses, allowing me to quickly and easily fill a page of writing about this one word. From that writing I chose the sentence used on the back of the card. [Questions will light up the dark corners.]"

—Diane Becka

THE ALCHEMIST & GUIDED VISUALIZATION

The alchemists were scientists in search of the ability to change base metals into silver or gold. They thought this would be possible if they could find the philosopher's stone. There is something magical about the belief in experimenting, in keeping notes about what works and what doesn't work. Doesn't your studio space feel magical sometimes? Don't you feel that you can change the world (or your heart) from a worktable?

Just when you feel that way, of course, the inner critic shows up to suggest you will never achieve that dream, that level of ability, that secret goal.

That's why an inner hero Alchemist is a good idea. She will help you explore and experiment when the inner critic shows up to tell you that experimenting is a great risk to what you already know. Yes, you might learn something new and have to change. You may even have to give up an old technique or idea because it no longer serves your creativity. But it's irresistible to try something new.

You don't have to know what the Alchemist looks like or know how to draw. This chapter is about calling forth that part of you that is curious about life, wonders what might happen if you explored something different or tried a new way of using a well-loved technique.

In this section we are going to work with fabric and see how it can be used in journaling as color, as texture and . . . as fabric. Woven fabric imitates our lives—many strands coming together to make a new whole.

The gift of the inner hero Alchemist is belief in magic and belief in yourself. You get in touch with your inner hero Alchemist by experimenting with new products or new techniques, or using familiar techniques in new ways. The Alchemist in you allows you to play and move into discovery without constant fear that you will do it wrong or mess it up. The Alchemist lets you think *What if I . . . ?* and come up with many right answers. You might believe there is only one right answer to your creative questions, but there are many. What you learn today will add to what you discover tomorrow.

The inner critic often shows up when you are experimenting to tell you how something won't work. The inner critic might be right—some experiments may not work the way you think they will, but if you give up, you won't learn anything new.

For example, when I began working on the leaves in the Gardener section, my first experiments didn't work. The leaf surface was waxy (most desert leaves are waxy to prevent precious water from evaporating out of the plant) and didn't take ink well. I could have quit then, but I didn't. I tried scrubbing the leaves, and that worked well—for a while. But the leaves then became brittle. I tried coating them with gesso, and that worked really well, except the leaves looked white, as if I had cut them out of paper. Finally, I experimented with coats of matte medium, gloss medium, PVA glue and a mix of glue and ink. All of those worked really well. There were some experiments that didn't work, and many that worked well.

Fabric and Paper Collage

If you are a paper artist, you will love adding fabric to the mix of materials you use. Fabrics create texture, color and layers that open big new possibilities in art journaling. You can layer sheer materials over a page to create a mood. You can make a series of drawings and cover them with different sheers to create a sense of moving time. You can find fabric with letters to cut out or images to use. You can write on fabric. You can even print on fabric, using your inkjet printer.

Best of all, you do not have to know how to sew to try any of the exercises in this chapter. It helps if you have a simple sewing machine, but you can do most of these exercises by hand-stitching, too.

Fabric printed with graphic elements can be a design inspiration. A quilting store can be your color inspiration, too. If you love a patterned or batiked fabric, you can choose colors from the swatch and feel comfortable that they will work together.

Guided Visualization

Guided visualizations help you unleash your imagination and let it run free. In a guided visualization you listen to someone describing a scenario (you are going to visit your inner Alchemist in the one in this chapter) and imagine what happens in great detail. Your intuition and imagination unite to bring you images that come together into scenes. The scenes help you come up with ideas for pages, and the answers to your questions reveal details about who you are as an artist.

There are four steps to the guided visualization you will experience in this chapter:
1. Preparing and relaxing
2. Imagining your trip to the Alchemist
3. Returning from your trip
4. Capturing your experience

Guided visualizations are fun and helpful. You are not hyp-
notizing yourself. You are not losing control or shifting to
another reality. You are giving yourself permission to pay
close attention to your imagination and let your intuition
guide you to discoveries about your art and yourself.

Cut-out fabric letters stitched over a printed fabric postcard.

find fun bonus content from this book at www.artistsnetwork.com/innerherocreativeartjournal.

53

The Magical Symbols of Alchemy

Alchemy is often referred to as "The Great Work" of discovery and transformation. This is the work of all of us who journal—to make meaning of our lives, to discover who we are and why we are here. *Alchemy* comes from the Arabic word *al-kima*, which the Egyptians used to talk about a long life.

Alchemy was not just about turning base metals into gold, but also in linking the macrocosm (the universe) to the microcosm (our journey through life). The related Arabic word *kimia* came from the ancient word for Egypt, *khem*, which meant "black earth" (the fertile soil of the Nile delta, contrasted with the surrounding red desert sand). *Khem* may also have referred to the original primordial ooze from which life emerged. If you think of alchemy and the *khem* of soil, it's a quick step to *chemistry*, and *chemurgy*, now called biochemical engineering. Alchemy is a rich field of stories, experiments and symbolism.

The essence of alchemy is change and transformation. The symbols of alchemy aren't universal. There are many different symbols for gold, other chemicals, even processes. The symbols are interesting and can become part of your iconography on the pages you make for your inner Alchemist.

If you do an image search for *alchemical symbols*, you'll find many examples. You can use them as margin decorations or as focal points.

Attaching Fabric & Paper— Some Basics

If you are a paper artist, you attach pieces of paper by using some sort of adhesive: acrylic medium (which is acrylic paint without any color in it), PVA, rice paste, paper tape, glue dots, double-sided tape, etc.

If you sew, you use thread or embroidery floss to hold pieces of fabric together.

Paper can be sewn together, too, but gluing fabrics can result in wet spots that change the fabric.

The freezer paper trick. You can temporarily attach fabric to paper by using freezer paper, which has a coating of wax or thin plastic. When you place the fabric on the shiny side of the freezer paper and iron it, the fabric sticks flat to the paper, allowing you to trim it to size and run it through your inkjet printer. There are three things to watch out for in this trick:

- Place the back of the fabric (the side you don't want to print on) on the freezer paper.
- Carefully trim the page to size for your printer.
- Feed the fabric/freezer paper into your printer so the fabric gets printed, not the paper.

After that, run wild with exploring!

The precut printer fabric trick. Quilters use a special fabric that is already attached to paper and ready for your inkjet printer. The fabric is cotton or rayon, plain white or cream, and you feed it through your inkjet printer before cutting it for your project. It's colorfast, but you will need to iron it after printing to set the color.

There are many brand names of printable fabric; they usually come three sheets to an envelope and vary in quality. While the better-quality ones aren't cheap, they are very easy to use. You also have the choice of stitching the printed piece onto the background or using a type that irons on.

The fusible webbing trick. Fusible webbing is a sheet of glue for fabric. It looks like interfacing, and you buy it like fabric, but it irons into place. It comes either one-sided or two-sided, and each has a different use.

You can use one-sided fusible webbing to stiffen delicate fabrics (to make it easier to appliqué), to hold the pieces of a fabric collage together or to keep slippery fabric flat.

Two-sided fusible webbing is the glue to use to attach fabric to paper or fabric to fabric. The results are fast and easy. You need to be careful not to let the webbing melt onto the iron, but that's what parchment paper is for. (Specific directions are in the step-by-step projects.) A little practice and you'll be creating amazing pieces with fabric and paper.

Watercolor pencil sketch printed with an inkjet printer on cotton sheet, emphasized with watercolor pencil and sprayed with glittered ink.

Fabric & Paper Collage

Before You Start:

To create a fabric collage you will need a choice of fabrics. Building a stash is addictive, so it's smart to start with small quantities. You can ask your friends who sew to trade some of their stash for some of your art supplies, or you can buy "fat quarters" from a quilt store. Instead of cutting a quarter-yard strip of fabric from a bolt to give you a piece that's relatively narrow but fairly long, a fat quarter is cut at 18" x 22" (46cm x 56cm). Both the quarter-yard from the bolt and the fat quarter measure 396 square inches (2,555 square centimeters), but because of the shape, you can cut larger pieces from a fat quarter. You can also buy a fat eighth (11" x 9" [28cm x 23cm]). Fat quarters and eighths give you a choice of fabrics without a big outlay of money.

Fusible Tip

Mistyfuse (both the white and black) can be painted with acrylic paints. The black color is attractive when streaked with gold or copper. Allow the paint to dry before you iron it on as a decorative graphic element.

WHAT YOU NEED

iron and ironing board

5" x 7" (13cm x 18cm) 140-lb. (300gsm) cold-pressed watercolor paper (Strathmore Ready Cut)

fusible webbing (no color)

fabric for background and butterfly-print fabric

parchment paper

scissors

fusible webbing in black (Mistyfuse)

peacock feather

paintbrush

glue

sewing machine

thread to match background fabric

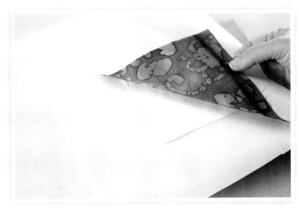

1 On a protected ironing board, layer a "sandwich" in the following order: the watercolor paper on the bottom, double-sided adhesive webbing (I used Pellon Wonder-Under), the fabric (cut ½" [13mm] larger on each side than the paper), and topped by a sheet of parchment to protect the project and your iron.

2 Preheat the iron to the Cotton setting and press the fabric sandwich. Avoid twisting the iron, or you will misplace the fabric. Press down, and then move, and then press again. Do not leave the iron in place more than ten seconds without checking adhesion.

3 Test to make sure the fabric adheres to the paper at the edges and corners. Then trim the fabric flush with the edge of the watercolor paper.

4 To attach the peacock feather, first cut small pieces of a dark-colored adhesive webbing (I used Mistyfuse in black) and place the webbing on the fabric, under the feather fronds. The webbing will show after ironing, but it is subtle.

5 The shaft of the feather will not adhere with fusible webbing if it is too stiff or broad. Trim the feather to the edge of the paper, and then use a paintbrush to put glue on the bottom of the feather shaft and press it against the fabric. Hold it until the glue sets.

6 Using the butterfly-print fabric, choose a butterfly that works with the color of your fabric. Trim the butterfly from the fabric. (Cut off the antennae rather than try to trim around them. You can draw them in with an ink pen after the butterfly is placed.)

find fun bonus content from this book at www.artistsnetwork.com/innerherocreativeartjournal.

57

7 Place the butterfly right side down on your work surface. Cover it with adhesive webbing (I used Mistyfuse in black). Carefully trim the adhesive to the size of the butterfly.

8 Place the adhesive and butterfly (right side up) on your page so it covers part of the feather's edges. Part of the butterfly is off the page. This gives the piece a carefully designed look instead of a flat, ironed-on look. Slip a piece of parchment paper underneath the project to protect the ironing board. Cover the butterfly with parchment paper to prevent sticking, and iron using the Cotton setting. Part of the butterfly is off the page, but has adhesive. The adhesive helps the butterfly stick to the edge and supports a clean cut.

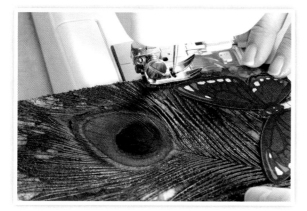

9 Trim the butterfly to the edge of the page. Thread your sewing machine with a thread that matches (or contrasts, if you prefer) the fabric under the feather. Using a zigzag stitch, finish the edge by sewing around the page. Position the needle so one part of the zigzag falls on the page and the other side falls just off the page. This binds the edge beautifully.

WHAT YOU NEED

good cotton paper (I use Arches Velin), about 6" x 8" (15cm x 20cm)

thread, both on spools and on bobbins, several colors

sewing machine

paintbrush

watercolor pencil

gel pens or markers, several colors (Use dye markers like Pitt rather than alcohol markers like Copic, which will soak through Velin, or you can use watercolor pencils.)

glue

5" x 7" (13cm x 18cm) 140-lb. (300gsm) cold-pressed watercolor paper (Strathmore Ready Cut)

pencil

scissors

Sewing on Paper

This is an easy, fast technique that will give you good results quickly. While it sounds simple, you can easily make it more challenging, more colorful, more interesting. Let's start with the basics.

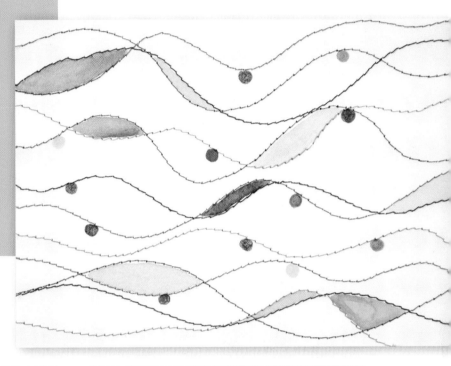

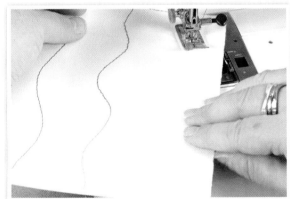

1 Another type of page to use for the Alchemist is one that uses stitching, drawing and writing, in any combination you enjoy. If you sew directly on the card, the lines will appear on both the front and back. In this project you will use a separate sheet of paper to sew on, allowing the back of the card to remain free for a different background. Cut a piece of 100 percent cotton stock (I used Arches Velin) slightly larger than your 5" x 7" (13cm x 18cm) page.

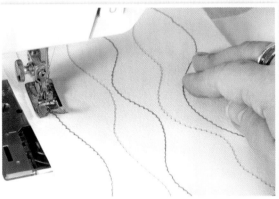

2 Choose several different colored threads and a bobbin for each thread. You can mix bobbin and thread colors for an interesting effect. Begin by sewing a straight stitch in color 1 down the length of the page, while moving the page back and forth gently. You'll get a long, undulating line.

find fun bonus content from this book at www.artistsnetwork.com/innerherocreativeartjournal.

59

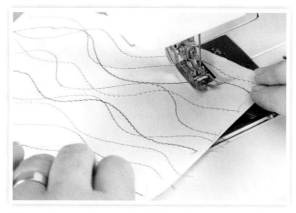

3 Leaving the thread and bobbin in the machine, stitch along the edge, moving the needle about 2" (5cm) over and repeating the stitching. By doing two or three rows of each color thread, moving the page each time, you'll save time re-threading the machine. The final piece should have different colored stitches, with no consecutive lines in the same color.

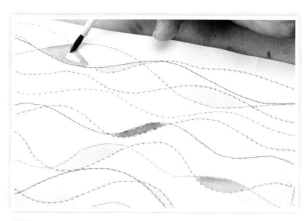

4 Stroke a damp brush against a watercolor pencil to pick up color, then fill in some of the stitching spaces with color. Repeat until you have different colors scattered across the page.

5 Use a gel pen or a colored marker to draw contrasting circles on or between the lines. Distribute the colors for a bright, confetti design.

6 Position the 5" x 7" (13cm x 18cm) page on the back of the stitched sheet. Use a pencil to mark where the sheet will be glued and remove the page. Along the pencil line, glue the threads down.

7 Glue the 5" x 7" (13cm x 18cm) page down on the back of the stitched paper. Trim the excess stitched paper from the page using scissors.

Sewing on Paper Variations

• For more interesting pages, use metallic threads or variegated threads.

• You can also make the pages monochromatic by using shades of one color.

• For a completely different effect, stitch on black paper using metallic or light thread.

Sewing With Other Papers

There are many more ideas you can use if you like sewing paper and fabric.

• Sew layers of tissue paper—white or colored—onto a piece of paper. Tissue that comes in colors are not always colorfast and may run when wet. Check before using. Each offers something different. Spray colored tissue with water and allow the color to spray, soak or spread onto the white tissue.

• Layer tissue, then tear part of it away. Stitch two rows close together, then leave a bit of space, then sew two more rows close together. Continue this pattern across the width of the page. Using a pair of tweezers, pull the tissue in the wide area away from the background.

• Use the sewing machine and a free-motion foot (an attachment that allows you to move in different directions without causing thread disasters) to write on the page. This takes a little practice. Start with loops and free-form designs, then move on to simple words.

• You can free-motion stitch on paper, too, then fill in the letters with color.

• Sheer fabrics such as organza, tulle and netting can add layers of shading and mystery to your pages.

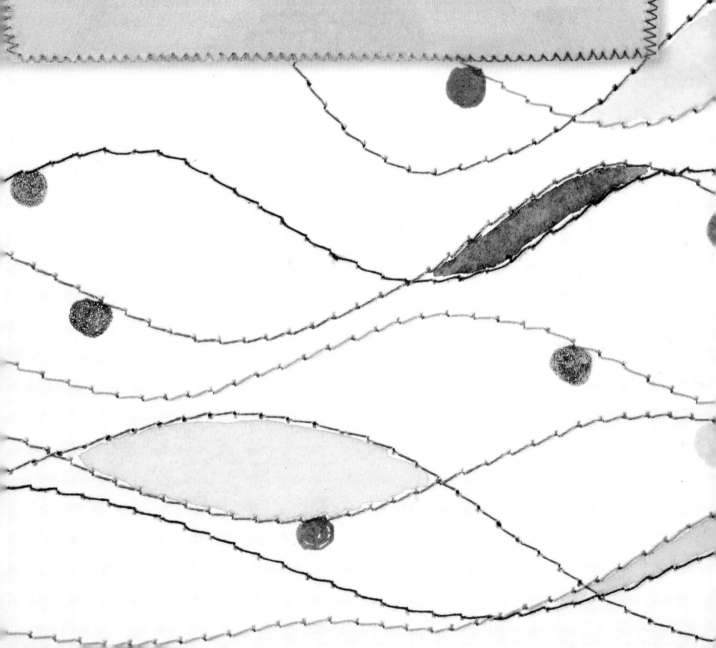

The Alchemist's Writing Technique: Guided Visualization

A guided visualization is a way for you to set your imagination free to chat with your intuition. Guided visualizations are scripts that you listen to while imagining yourself in a wonderful setting talking to interesting people. Anything positive, healthy and incredible that you can imagine can happen in a guided visualization.

Before You Start:

In a guided visualization you set aside thirty minutes of time where you will not be bothered by anyone. Turn off your phone, computer, anything that may distract you, including a TV or music. You are not listening to music; you are preparing to listen deeply to yourself.

A guided visualization is meant to be listened to, not read. If you read it and then simply replay the trip in your head, it will not be as powerful. I've included a short one below, which you can record and then play back and listen to with your eyes closed. You can personalize it for your tastes. If you don't like butterflies, for example, you can substitute birds.

How do you record it? There are apps for your phone or your tablet computer that allow you to record messages. If you don't want to download one, you can also read the message into a voice mail message if your phone will allow a long message. Or you can ask a friend to read it to you slowly and not speak to you about anything else.

Settle yourself into a comfortable position in which all stress points on your body—head and neck, back, knees and feet—are supported. Arms should also be comfortable and not crossed, and your eyes closed.

1. Relax deeply. You can do this by imagining yourself in a beautiful location, one that is perfect for you. Then deliberately tense and relax your muscles, starting with your feet and working up through your legs, your pelvis, your chest, neck, shoulders, arms and hands.
2. As you relax, you breathe slowly, deeply and regularly in through your nose and out through your mouth, watching yourself relax. If you are living a life that is out of balance or very stressful, you may fall asleep at this stage. Don't worry if that happens; just be aware that you need more sleep.
3. While you are listening to the visualization, imagine with all five senses: seeing, hearing, touching, smelling, tasting. The deeper you imagine, the more you will experience. Keep the images clear and sharp so you will remember them.
4. When the visualization is complete, turn to your journal and write down all of the details you want to remember, especially the detail of your conversations.
5. Return to your journal the next day, and see how your memory has changed and whether or not what was unclear yesterday is clear today.
6. A guided visualization can be used often but not in successive days. Spend about a week thinking and learning before you repeat the experience. Waiting longer is fine, too.

Meeting Your Inner Alchemist

Have a friend read to you the following visualization, or see Before You Start on the previous page for tips on recording yourself reading it.

WHAT YOU NEED

recording of visualization (see Before You Start, previous page)

quiet place

journal or notebook

pen (comfortable, reliable and that you can write quickly with)

Imagine you are walking down a hall in your house. The hall is quite long, and it takes you several minutes to walk down it. As you walk, you are aware of how comfortable you are and of a lovely scent in the air.

The hallway leads out of your house though a beautiful door. You step outside into a beautiful day. Feel the temperature. Feel the warmth of the sun. Then walk into the garden that's right in front of you. It's gorgeous with flowers blooming and butterflies flying through the flowers. Look at the flowers carefully. Notice the colors and textures. Notice the movements of the butterflies, how lightly they land and take off from the flowers.

Notice the fountain in the garden. There is a bench next to the fountain. Sit down and enjoy the sound and the fresh breeze blowing over the garden.

After you have enjoyed the garden and fountain, get up and see a path through the edge of the garden into a field. Walk down the path and enjoy the view. As you walk, you see that you are going to enter a beautiful forest filled with areas of sunshine and shade. Smell the trees. Feel the bark on some of them. What does it feel like?

Continue to walk through the forest, noticing the birds and small, friendly animals that you see. Which animals are your favorites?

As you come into an area of sunshine, you see several comfortable chairs. You know you are supposed to sit in one of them. You sit down, and as you do so, you hear a voice that says, "I'm so glad you are here. I've been waiting for you." You turn and the Alchemist is standing in the path, smiling. She sits down in the other chair.

The Alchemist makes you feel very comfortable. She seems to know a lot about you, and you spend time talking about your creative projects and what causes you to stumble in your work. The Alchemist listens carefully, understanding you deeply.

You know the Alchemist changes one thing to another; that's her skill. And there is something you want to change in your life. What is it you want to change? Ask the Alchemist about it. Choose your words carefully.

The Alchemist listens and nods. You feel fully heard. Then the Alchemist leans forward and whispers a word in your ear. What is that word? Don't make something up that you think you should hear, just listen and hear it. You may have to wait a few seconds for your mind to clear. Do not force anything. Just listen. You may not understand why you heard the word, but trust it. Remember the word.

Now the afternoon is coming to a close, and it is time for you to return. You are grateful that the Alchemist had

find fun bonus content from this book at www.artistsnetwork.com/innerherocreativeartjournal.

63

time for you. She tells you that she is always available to you, and you are always welcome to visit her.

You get up from the chair and walk down the forest path. The light has changed, but it is still a happy, welcoming place. You notice the animals again and how they are not scared of you, and you feel comfortable with them.

You are excited about the conversation you had with the Alchemist. The word is important, even if you don't know exactly what it means yet.

You come out from the forest path and walk into the field, where the sun is not far from setting. The light is so beautiful at this time of day. You continue to walk until you come to the garden and fountain. You spend a few minutes looking around at the great beauty in the flowers and the flowing water.

Then you stand and walk toward your own house again. As you come to the beautiful, magical door, you turn around and watch a breathtaking sunset. As the sun disappears behind the horizon, you step inside your own home, safe and happy.

[If a friend is reading this to you, the friend should see you open your eyes, and then quietly leave the room without speaking or looking at you again.]

Slowly allow yourself to become aware of your surroundings. Stretch and feel how relaxed you are. Do not speak to anyone until you have found your journal and written responses to the following questions.

Guided Visualization Questions for the Alchemist

- What were your favorite flowers in the garden?
- What animals did you see in the forest?
- What did the Alchemist look like? Was this what you expected?
- What was the change you discussed with the Alchemist?
- What was the word the Alchemist gave you?
- Do you know what the word means in your life? (It's OK if you don't right now.)

Write down some possible meanings of the word. Don't limit yourself to the literal, exact meaning of the word. Think about a metaphorical meaning. For example, if the Alchemist said "stone" to you, you may think of it as the philosopher's stone, which will help you understand things you do not understand now. You may have to think about what has great meaning to you that can help you solve problems or how you want to change your problem-solving techniques.

You may also think of it as a hard surface to support you. Or you can think of it as a grinding stone to polish your ideas. Or even a weapon to use. After you have written in your journal, close the journal, take a deep breath and return to your routine. Revisit the journal the next day or even for the next few days to explore the meaning of your visit with the Alchemist.

After you have completed several pages of journaling, look at what you have written and circle the parts that are meaningful to you. Summarize the best parts into short, practical sentences. Write sentences that the Alchemist might use to offer real help when you need it. You may have more than one answer. That's fine; you can have more than one Alchemist page. You can make many because there is always more work to be done in facing your inner critic.

Creating a Background for the Alchemist Page's Journaling Side

If you used fusible webbing to hold fabric to one side of the page, you can use another color fabric for the other side of the page. You can write on fabric with gel pens or permanent markers.

You can print your writing portion on interesting paper (ironed onto a piece of freezer paper) and fuse it to the back of the peacock feather collage. You can also print your writing portion onto a piece of iron-on fabric, cut it out and iron it onto the background.

If you created a stitched page on a sheet of another paper and then attached it to the watercolor paper, you have a completed page whose writing side has no lines. For this page you can create a postcard. Whether you make it to send or you make it to keep, the page will look like a message from someone important.

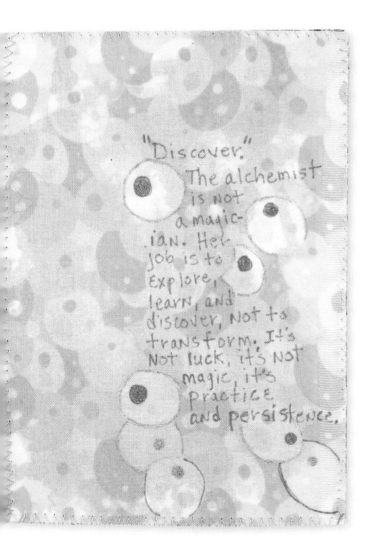

WHAT YOU NEED

fabric collage Alchemist card (from the first art exercise in this chapter)

rubber stamp that makes a page look like a postcard

colorful ad from a magazine

index card

scissors

postcard stamp if you are going to mail the page

glue

find fun bonus content from this book at www.artistsnetwork.com/innerherocreativeartjournal.

65

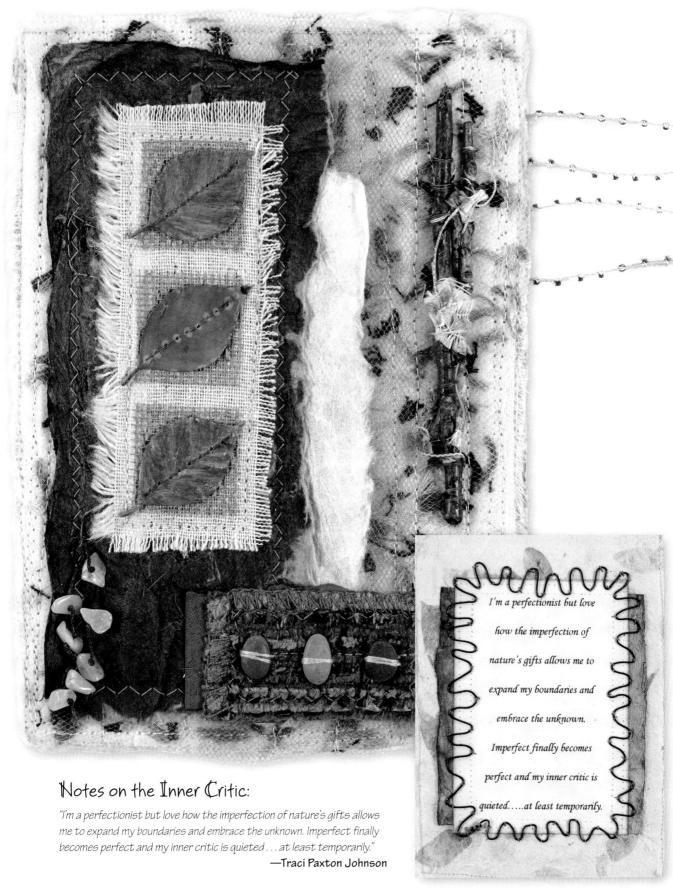

I'm a perfectionist but love
how the imperfection of
nature's gifts allows me to
expand my boundaries and
embrace the unknown.
Imperfect finally becomes
perfect and my inner critic is
quieted.....at least temporarily.

Notes on the Inner Critic:

"I'm a perfectionist but love how the imperfection of nature's gifts allows me to expand my boundaries and embrace the unknown. Imperfect finally becomes perfect and my inner critic is quieted . . . at least temporarily."
—Traci Paxton Johnson

THE GARDENER & TOOL IDENTIFICATION

Even if you don't have a garden or have never grown an avocado or a sweet potato in a pot, you know the calming effect of the garden space. You've taken walks under trees and across freshly cut grass—barefoot. If you've had a garden, no matter how small, you know the thrill of seeing seeds go from grains in mud to the first two leaves, a real stem, then buds, flowers and wow! Nothing else tastes like a sun-ripened tomato or a crisp, cold pepper. If you are a garden lover, you know what it takes to produce those flowers and veggies—the weed pulling, the mulching, the soil preparation. You have known the thrill of seed catalogs that arrive in the chill of winter and begin to warm your imagination of what your garden will look like in spring.

The Gardener is a hero who combines a vision of what can be with the reality of what is right now. When a gardener holds a seed in her hand, she doesn't see a small speck of tan or brown; she sees a whole garden, vibrant and alive. She knows the power of that seed to push earth away and grow toward the sun at the same time the roots are digging down and anchoring the plant.

Wander Into the Greenhouse of Your Imagination

This section is about the growth of your skill in art journaling, the satisfaction of trying out new ideas and watching them blossom. If you have never used natural materials in your artwork—leaves, sticks, dried flowers, even eggshells—you are about to discover a new joy. These natural designs can be used as is, as substrates or in collage and assemblage. You can also draw them or copy them onto patterned paper and create new leaves and blooms.

As is true in the other sections, none of the satisfaction of this chapter demands that you know how to illustrate or paint. The satisfaction comes from the joy of creating and identifying with another inner hero.

In the writing section you'll discover that the Gardener's tools for watering, pruning, weed removal and plant support have a close relationship to nurturing, guiding and expanding your creative exploration. You'll develop some new tools to manage your inner critic, and your Gardener inner hero will demonstrate how to know what's useful from the inner critic and what can be pulled out like a weed.

Call on the Gardener when you feel too tender for a blast of criticizing frost or too scorched by lack of progress in your work. When the inner critic demands more projects, more work in new areas, the Gardener as hero will bring the pruning shears and show how focus on a single direction helps you save your strength for where it does the most good.

Planting Seeds & Artful Leaves

The art techniques for the Gardener help you free yourself from using the same supplies and techniques of the past. Using natural found objects will give you a new appreciation for color and texture. Natural objects are already perfectly imperfect. You can draw them and combine drawing and leaves, but you can also create assemblages of natural objects that help you remember your natural talents and gifts.

You'll try out some ideas, and then create a seed packet on a page to remind you that many ideas can bloom in your art journal. There are endless possibilities here as there are in a garden. Your art journal can be as ethereal as an annual flower garden or as sturdy as a vegetable garden. Both nurture different parts of the creative you.

Picking the Best Tools

The writing technique helps you consider the Gardener's tools as spiritual growth tools. Choosing tools wisely, the Gardener controls weeds and plants seeds at the right depth. She chooses a technique to water gently instead of in a rush that washes out seeds. Those tools represent techniques that help you nurture your work in your own time to grow toward your own light. Less competition, more meaning-making. Less feeling *I must get it done"* and more nurturing the inclination toward supporting kindness to yourself.

Creality Check

T. J. Goerlitz, the contributor to the Tarot Reader chapter, told me about Creality. She explained it as "the distance between your original idea—your perfect vision of creativity—and the reality of the completed project." It was such a great description of the distance we cross to get from idea to completed page or project.

Sometimes we don't make it all the way across. Sometimes the idea is rich and flawless while the result we make is not. That's the time to call the inner hero over for a talk. You can learn from mistakes. You learn problem solving by making mistakes. You learn to adapt your original idea. You learn to shed perfectionism. You gain from practice, adapting and growing toward your talent instead of wishing you were someone else. Creality is an important step in meaning-making.

Ripening
Poppyseed heads

Collecting Natural Elements

1. Collect pieces from your own yard or from a public area. Never pick leaves from trees or blossoms from a private yard.

2. If you pick leaves, seedpods, small branches (they make interesting writing implements) or pebbles from the ground, look before you touch. Dogs wander in the same area that you do. Feathers are tempting, but all feathers of migratory birds and endangered birds are illegal to own in the U.S. (Migratory Bird Treaty Act, 16U.S.C. 703-712). You may collect feathers from feral pigeons, house sparrows, nonmigratory pheasants and starlings safely. You can also purchase dyed feathers in craft stores.

3. Seedpods, leaves and blossoms are fragile. Choose leaves in good shape. Dry leaves can work as long as they are not brittle. Carry a hard-shelled container (an old sunglasses case works well). Or use a small, acid-free sketchbook, tucking the leaves or blossoms between pages, one to a page. When you are done, close the sketchbook with a rubber band.

4. When you get home, wipe the leaves on both sides with a damp paper towel. Wash rocks as well. Not all flower petals or blossoms can be rinsed, but sturdy petals (roses, for example) can be sprayed with water, then blotted dry, then left to dry completely.

5. When the leaves and petals are completely dry, place the leaves on acid-free, heavy paper (several sheets from the sketch pad will work). Do not allow the leaves to overlap. If the leaves are not completely dry, they will mold and be unusable. The same is true for petals. Don't mix leaves and petals on the same page; their different thicknesses will cause the thinner flower petals to shrink and warp. Put two plain sheets between each layer of flowers or leaves to distribute the moisture. Put the stack on a flat surface and pile some heavy books on it. Leave it for a week before peeking.

Saving leaves, petals, seeds and twigs is a seasonal activity. Use spring, summer and fall to gather materials so you will have them for winter. Pick flowers just before their peak, in the morning, and take them apart as soon as you get home. Discard the part of the flower that has pollen on it as it will stain paper and other petals. Cantaloupe and honeydew melon seeds make great design elements, but they must be completely dried before use. Once they are dry, try spraying them with a gold or pearlescent ink, then letting them dry again before use.

Patterned Leaves

Before You Start:

You'll be using real leaves for this project. If it's winter and no leaves are on the trees, that's fine. You can cut out leaf shapes from paper, purchase skeletonized leaves or even use silk leaves from artificial flowers and branches.

WHAT YOU NEED

acrylic glaze (matte or gloss) or PVA glue

plastic lid (approx. 3" [8cm] diameter), foam egg carton or foam meat tray—something with a small lip—to use as a palette

parchment paper

dried and pressed leaves

no. 4-6 flat-tipped inexpensive brush, for gluing

black permanent markers (e.g., Faber-Castell Pitt or Micron) in a variety of line widths

gel pens (black, white and gold as well as other colors)

acrylic paints or inks (several colors, including black, white and gold)

waterproof pen

1 Look over your group of dried leaves and discard any leaves that are brittle or have brittle tips. Pour a teaspoonful of glaze or PVA glue on a palette such as parchment paper. Glaze will dry more slowly than PVA glue, but gloss glaze dries completely clear and will make all the paint and lettering appear crisp. Multiple layers of matte glaze or a heavy layer of PVA may dry with a hazy appearance.

2 A broad flat brush is good for coating the leaves. Dip the brush in water, blot, then in glaze or PVA glue. Use long, slow strokes to paint the leaf. Avoid making streaks or bubbles.

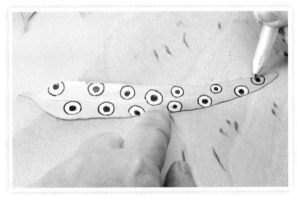

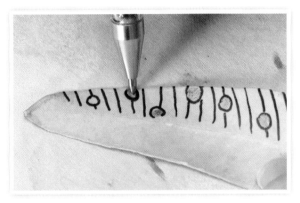

3 To make white and black circles, start with the inner circles. Use a permanent black marker to make several small solid circles on both sides of the center vein. Allow the marker to dry. Use a white gel pen to make a wider circle around the black center. Finally, add a black circle around the white circle to cover any small mistakes and give a finished look.

4 As a design variation, use a black permanent marker to make staggered circles on only one half of the leaf. Add lines from the center vein, slanting slightly toward the top of the leaf, interrupting them when they come to a circle. On the other half of the leaf, you can paint a layer of gold acrylic mixed with glaze. Clean and simple designs work better than busy designs.

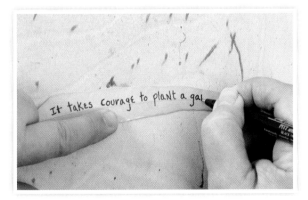

5 Once the first coat of glue is dry, you can write on it with a waterproof pen. Choose a favorite saying, lyric or intention and print it on the leaf. Practice on a blank piece of paper first to make sure all the words will fit.

Additional Ideas for Painted Leaves

• Mix two drops of gold acrylic paint into a teaspoonful of glaze. Mix thoroughly. Use this as the base coat on the leaves for a hint of shimmer.

• Substitute gloss medium with matte. The difference is subtle but effective.

• Try decorating only half of the front of the leaf instead of the whole leaf. Leave the other half blank or cover it with a solid color.

• Write a word that reminds you of your inner hero Gardener on the leaf. One word (grow, thrive, reach, roots) may be enough. You can also write a short sentence as a secret message on the back, using a felt-tipped pen.

Seed Packet

If you paint one side of the leaf and write on the other, you might want to keep both sides visible. By creating your own seed packet, you can store leaves safely and take them out to look at them whenever you wish.

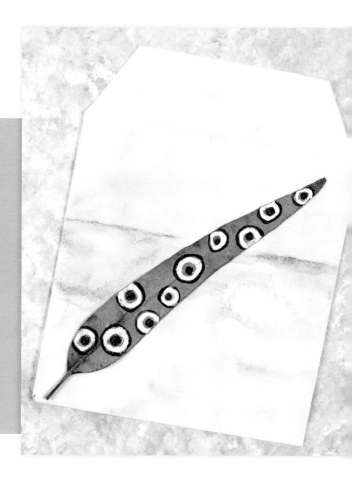

WHAT YOU NEED

cotton paper, letter size, about 90-lbs. (190gsm)

seed packet template

optional: image for the seed packet

scissors

ruler or bone folder

paintbrush

watercolor pencils

glue

optional: acrylic paint and natural sponge

optional: metallic or pearlescent paint

parchment paper

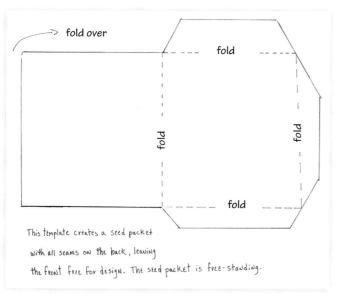

This template creates a seed packet with all seams on the back, leaving the front free for design. The seed packet is free-standing.

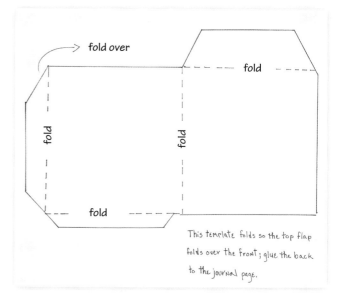

This template folds so the top flap folds over the front; glue the back to the journal page.

Download this template at www.artistsnetwork.com/innerherocreativeartjournal.

72

sign up for our inspiring and free newsletter at www.artistsnetwork.com.

1 Cut out one of the templates for your seed packet and using a ruler or bone folder, score and crease the folds. Use a good cotton paper.

2 Use a wet brush and watercolor pencils to create a misty background for your seed packet. Brush water over the paper to dampen it, and then touch the color to the paper, letting the color drift. Keep the brush wet with fresh water.

3 Position the leaf you will attach to the seed packet where you'd like it, and glue it in place.

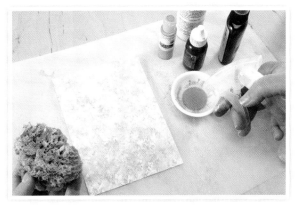

4 If the package is going to be attached to a page, sponge the page by putting acrylic paint on a natural sponge and pouncing it lightly on the surface. Use two to three coordinated colors for a rich effect. A metallic or pearlescent paint adds a nice touch.

5 Glue the seams shut to complete the packet.

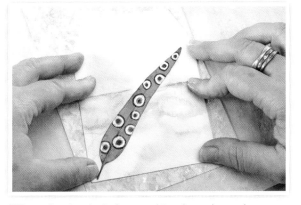

6 Let the glue dry before attaching the packet to the page. If you are attaching the package to hold future intentions or leaves, glue it so the flap is open and facing the background page. This will hold the contents more securely and allow you to stack pages. To keep the project flat and usable, put a piece of parchment paper over the page and weight it down with a heavy book overnight.

find fun bonus content from this book at www.artistsnetwork.com/innerherocreativeartjournal.

73

Illustrating in Eggshells

Eggshells create a highly textured substrate that grows organically across the page. Because the texture gets a lot of attention and the eggshells are a delicate shade of white, it makes sense to use gentle drifts of shell pieces to enhance an image rather than create traditional, squared-up mosaics, as you did in the Tarot Reader chapter.

Use eggshells in only parts of the illustration rather than the whole illustration. Using texture to create shapes allows you to suggest rather than create an outline. You can paint the eggshells or leave them natural or use a mix of both. The idea here is not to create a complete mosaic, but to add texture to a simple drawing.

Keep the design simple. A horizon line, a spot for the sun and one major element (a flower or vegetable) in the foreground is enough to start. Since this is the Gardener's section, the example here shows a pear placed on a green and gold background. Pears come in many colors and shapes, from yellow to green and rusty red. Their shape makes interesting shadows and curves. Pears are also a good source of metaphors. They are one of the few fruits that do not ripen best on the tree. Pears need to be picked before they are ripe. If left on the tree to ripen, they become gritty and the core turns brown. Pears need a steady temperature and enough time to ripen fully for best flavor.

Before You Start:

Collect and clean shells from eggs used in cooking. They can be cracked open; you do not have to blow out the egg-shell. Using tweezers, pull away and discard the membrane from the shell. It's OK if some of it does not come off. Put the shell pieces in a large container of cold, soapy water; weight them down with a plate so the entire eggshell is under water. Leave for ten minutes. Rinse each shell. Dry thoroughly upside down on a paper towel before using.

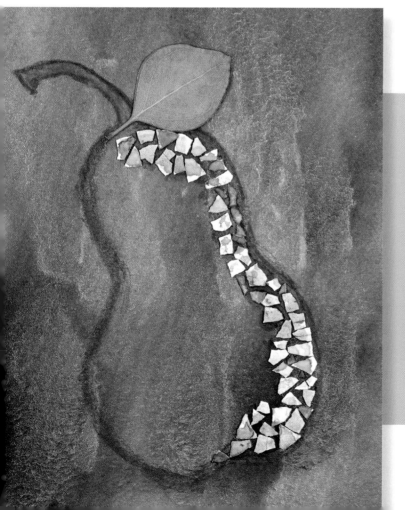

WHAT YOU NEED

5" x 7" (13cm x 18cm) 140-lb. (300gsm) cold-pressed watercolor paper (Strathmore Ready-Cut)

inks, including metallic ink

watercolor paints and pencils

water pen

shell from one egg, cleaned and dried

PVA glue

inexpensive flat brush for gluing

round paintbrushes, a fine one, about size 3, and a wider one, about a size 6

optional: dried flower petals or leaves

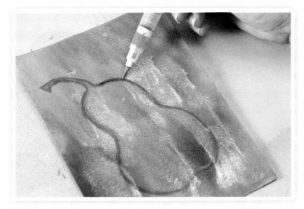

1 Prepare the watercolor sheet by painting it with inks. Using metallic ink as an accent gives the page depth. Draw the outline of a pear on the page, using a watercolor pencil. Go over the line with a water pen to soften the outline and shade in the stem.

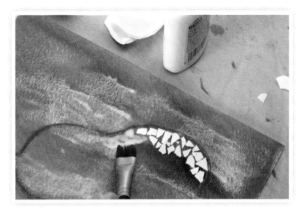

2 Break white eggshells into small pieces. Working in small sections at a time, put down a drop of PVA glue and spread it with a flat brush. Using a thin, round brush, dip it in water, blot, and pick up a piece of eggshell. Place it on the inside of the line, with the curved side up. Snug the pieces along the outline first, then move toward the center. Do not cover the shells in glue.

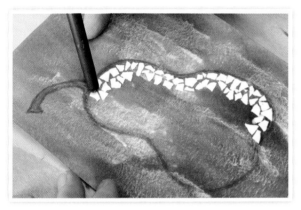

3 Place the eggshells on the side of the pear that faces the direction of the light—where the color would be brightest. The pieces should be close but not touching. If you place a piece of shell that is too large, use the handle of the brush to push on the curved shell until it breaks into several pieces.

4 When the eggshells are glued down, tint the shells using watercolor pencil. You want to soften the bright white as well as add a bit of shading between the top and bottom curve of the pear. Dip a brush in water and brush it along the pigment of the watercolor pencil. When the brush is loaded with color, brush it over the eggshells.

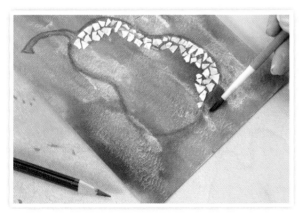

5 If the eggshells got glue on them, you can tint the shells with ink, which will cover the glue. Place a shadow under the pear so it doesn't "float" on the page.

The Gardener's Writing Technique: Identifying Tools to Confront the Inner Critic

The Gardener inner hero is a spirit guide for you. Her gift is her knowledge of gardening tools that can be used to confront the inner critic. Garden tools aren't all about weed control; there's also planting, nurturing and harvesting.

Planting	Nurturing	Weed Control	Harvesting
trowel	support/cage	hoe	shears
hoe	watering can	mulch	basket
garden fork	pruning shears	shade plants	gloves
markers	compost	hands	timing

Of course, you can add your own additional tasks to this and list additional or different tools.

Confronting your inner critic is not always about avoiding, banishing or silencing. Gardening is a subtle art. Knowing which tool to use when is the key to harvesting the best of what you plant.

Knowing how much to use the tool is also important. Pruning plants so the strength goes into the major branches results in an excellent harvest. Over-pruning damages the plant and reduces the harvest. No pruning at all results in a lot of fruit that can break the plant. Too much fruit also results in crowding and smaller fruit.

Before You Start:

Create a tool for confronting the inner critic based on the tools above. For example, garden markers are used for reminding you what you planted in a certain row. In your dealings with your inner critic, the markers might be the steps toward a project you want to complete, or the small successes you want to achieve on the way to a bigger success. The markers could also represent prior mistakes and a way to mark them so you don't repeat them.

Take your time in shifting your perspective from garden tools to inner critic tools. Write down several possibilities and consider which are most meaningful for you right now. You can make more pages as you grow, so you can always have a recent tool that makes sense to you.

The seedhead of fall holds the color of spring yet to come.

Using Your Tools With the Inner Critic

Once you have the tools that help you confront the inner critic, you will want to know how much to apply them. Create another list that has three headings: No use, Ideal use and Overuse. The purpose is to consider what happens when you use your gifts, strengths and weaknesses too much or too little.

Consider the tool and then describe what would happen if you didn't use it. This helps you find the right tool at the right time. Looking at your work critically can make it better. Demanding perfection the first time will make you throw out or hide every creative project.

Then consider what the best outcome would be if you used the tool in the ideal way. Focusing on the best outcome helps you prepare to *create* the best outcome.

Finally, consider what overusing a protective tool would look like. Knowing the first stage of overuse helps you recognize it when it happens and allows you to steer yourself away in the other direction. (Deciding the piece needs some shadow is a good first step. Using black gesso to cover the entire piece is going too far.)

To create these lists, imagine a conversation you might have with someone you know who is a great gardener. Keep your imagination on the side of creating ideas, not looking for problems.

This exercise is a matter of balance. Too little and the desired result doesn't happen; too much and the desired result gets pushed out of proportion and is exaggerated.

Imagine the volume control on your computer. Too quiet and you can't really hear what is being said. Too loud and the sound is distorted and your head hurts. Just the right volume is exactly the balance you are looking for to speak to your inner critic.

compost starts as trash.

By rotting, turns to gold

Composting takes time, but the results transform tired soil to rich loam. Time transforms. Time does the work.

In this image I deliberately made the top writing uneven and blurred to emphasize that compost starts as trash. The bottom writing is neater to remind me that patience and time transform. Notice that this backside of the page would also work in the Alchemist chapter, not only because of the drawn-in stitching but because of the reference to turning trash into gold.

find fun bonus content from this book at www.artistsnetwork.com/innerherocreativeartjournal.

77

Sample Conversation With the Inner Critic

Your inner critic says, "Don't draw that. You've tried it a million times, and it just doesn't work."

You think of a tool that would be useful here. The inner critic has a point—you have tried this many times. But you have a fresh idea you want to try, and you are in a good place, you have no expectations or deadlines to get it right. You need some support—like a tomato cage that helps the plant stay on the path upward instead of spreading out too far. The cage also offers support to a plant after the fruit sets. Fruits are like ideas. So you need support but not constriction.

Your inner critic is telling you that you should abandon support and just sprawl out, looking for a new idea.

You [listening to your inner hero Gardener]: "You are right. I have drawn a lot of this item, but I've also learned some new ways of thinking about it."

Inner Critic: "Thinking isn't drawing. You can't get this right."

You: "You don't really know that. I'm trying a new approach, and that gives me more structure than what I was doing before."

Inner Critic: "You'll fail."

You: "I might, but even if I fail, I will learn something."

Inner Critic: "You'll learn you shouldn't draw this item again. Quit, go take it easy for a while."

You: "I have enough time now to practice and experiment. I may not have that later on, so I don't mind taking the chance. I can take it easy tomorrow. Right now, I have work to do."

By giving yourself permission to support your ideas, the inner critic has lost his supportive ideas. The inner critic often bases his ideas on your weakness, so using small-step arguments that support your goal weakens his ideas.

Do you put the whole chart on the back of the card? No, that would be too much. Use one idea at a time, and make many pages, each with one support idea. Your inner critic will always come back, and the more cards you make, the more likely you are to be ready for him. Be prepared to stand up for your meaning-making.

Creating a Background for the Gardener Page's Journaling side

The space you create with this leaf pattern for the writing side of your Gardener page can be done on an unpainted background, or you can create the leaf print over a sponge-painted (or any other painted) background. If you want to use a painted background, you might wish to use a light, neutral acrylic paint and add a drop or two of brown acrylic ink. (Do not overmix.) Spray the page with water, and brush the mixture of ink and paint lightly over the paper, letting it streak. Let it dry before continuing.

To sponge a background, wet the sponge and squeeze it so the sponge won't drip. Dip in neutral acrylic paint mixed with darker ink. Spread the paint lightly and evenly over the sponge with your finger. Pounce the sponge over the page, covering most of the page. Let it dry. Repeat with just the light color. Then continue by adding the leaf design (shown here on an unpainted background).

1 To draw the leaves, draw one complete leaf in a corner with the gray brush pen. If you are drawing over a sponged or painted background, use a pen with waterproof ink, such as a Pitt pen.

WHAT YOU NEED

small sea sponge

broad flat brush, about ½" (13mm) wide

acrylic paint, neutral color (I used Golden's Titan Buff)

acrylic ink, coordinating color to tint the acrylic paint

spray bottle of water

light- or medium-gray brush pen

brown brush pen

2 Add more leaves around the first one, skipping over the "hidden" part. Turn the page as you work, adding leaves and leaving a blank space in the middle for words.

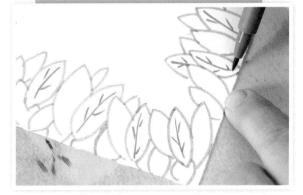

3 Add a center line and some veins in some leaves but not all. Use a brown pen for this part. You can then write the Gardener's wisdom in the center.

find fun bonus content from this book at www.artistsnetwork.com/innerherocreativeartjournal.

79

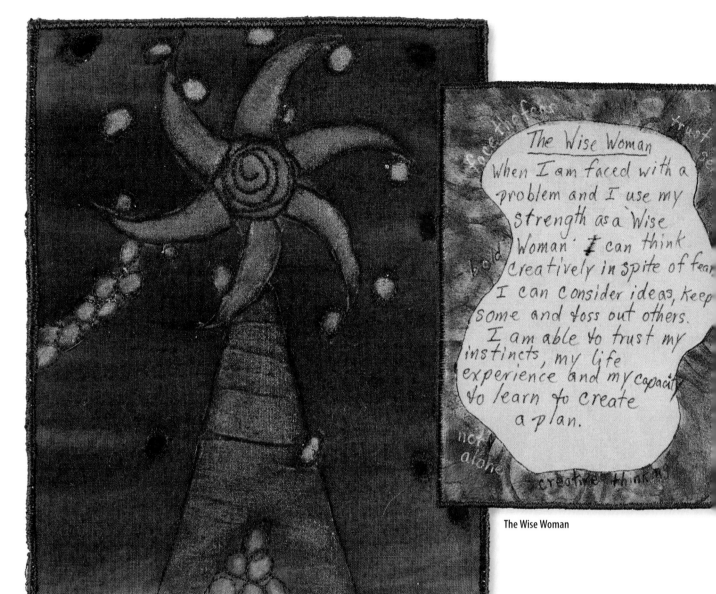

The Wise Woman

Notes on the Inner Critic:

"When I'm faced with a problem and I use my strength as a Wise Woman, I can think creatively in spite of fears. I can consider ideas, keep some and toss out others. I am able to trust my instincts, my life experience and my capacity to learn to create a plan.

"My inner critic can be loud and obnoxious. While I realize that she is there to keep me safe, sometimes I do not need protecting. Sometimes I need to step out and see what happens. The idea for my fabric piece came rather quickly. Once it was finished, my inner critic started her onslaught of exclamations that the piece was no good, could not possibly work, that Quinn would hate it, that the piece was stupid.

"This onslaught stopped me for quite a while; then I began to push back against the wave of negative statements and, tired of the back and forth, I sent Quinn a picture of it.

"Quinn loved it the way it was. Once I got that feedback, I was able to gag my inner critic because all of her protests had been proven wrong. Filled with relief, I could complete the finishing touches on the work and get it out with no further interference. If I did not push back against my inner critic, I would probably give up creating anything at all."

–Rosaland Hannibal

THE WISE WOMAN &
REVISITING WISE WORDS

When universities became popular and common centers of education in the eleventh century, women were often excluded. Being locked out of traditional medicine didn't stop women from practicing the healing arts, however. Women became midwives, nurses and herbalists, using plants to heal and soothe as well as cleanse, disinfect and restore. Their medicine, dished out in stories and in teas, is still powerful.

The Wise Woman offers patience and thinking things through. No rushing, just a slow developing of understanding and strength. She doesn't fear the inner critic; she makes him prove his claims, and often that's enough to make him slink off.

Just as the Wise Woman selects and gathers herbs, roots and wisdom, the page that honors her will use a variety of skills and techniques, methods and products.

Of course, you won't be drawing a Wise Woman, but you will be imitating her skill by reaching into your hidden stashes and using unusual supplies and methods of combining them.

Pull up a Chair on the Wise Woman's Porch

Wise women, generally experienced and older, became known as root women, herb women and crones. You went to them for advice, healing of spirit and body, and knowledge of plants, animals and nature. Men and women who feared the women's strength and knowledge labeled them as witches and tried to get them banned from guilds and participation in government and education. But the Wise Woman and her knowledge persisted, and she is ready to contribute to your journal.

You already have a bit of the Wise Woman in you. She helps you be curious about life and how things work. She shows you that discovery is important and trying something new can lead to improving the tried-and-true. She guides you to develop your own voice, not just follow the patterns of others. The Wise Woman is the voice of practical reason mixed with enough mystical vision to make creativity interesting. She is the quiet voice that makes you strong on your journey and willing to search for the answers that make meaning.

The Wise Woman also teaches you to laugh at yourself without feeling diminished. She reminds you that there is so much to learn, and you have a lifetime to enjoy the learning.

In your creative expression of the Wise Woman, you are going to combine techniques. None of the techniques in the book is dedicated to only one inner hero. You are free to invent, alter, mix, upstyle any of the techniques to suit your big, wild heart.

Just as the Wise Woman chooses from grasses, herbs and flowers to create the right mix of healing, you can choose techniques that inspire your inner hero to show you what you need at that moment.

Sometimes freedom of choice allows us to choose too much or combine things that don't work. (Bet you've done that on a few pizza orders!) That's part of this section, too. Try out combinations—will fabric mosaics work? What about leaf collages? The idea of this book is to encourage you to experiment with your creativity until you can communicate with your inner heroes and have them nurture you. Your inner critic will not let you run around feeling free unless you have a purpose, a goal and a selling point. Don't let him trap you in that corner.

Not everything you try will work, but nothing at all will work if you don't try.

Taking Notes With the Wise Woman

In order to remember an experience, you take notes and photographs. And you write in your journal. Writing allows you to remember the important moments and forget the ones that hurt you. Journaling lets you both gather and scatter. Sometimes you are surprised what you see in your journal, months after you wrote it. It's still a strong voice, a wise piece of advice or a hidden meaning that brings understanding.

Those quotes are the treasures you want to lift out of a journal page and put on the page you are making for your inner hero Wise Woman. You'll want to honor and remember them when you confront your inner critic.

Here's something I wrote months ago in my journal: "Retribution is like stabbing yourself a thousand times to punish the other person. You can start to change the world today. By being fair, even when you were not treated fairly. By being kind, even when people called you names." The rest of the story is not nearly as important as those sentences. Every time I read them, I know that I must act fairly even when the world isn't. In fact, it's more important to be fair when the world isn't. Because if I don't start it, who will? That's a powerful point to bring up to the inner critic when he chants a message of "everyone else has theirs, so now is the time to get yours and run."

Quotes develop and thrive in your journal. Don't let them hide there. Bring them out for a new round of meaning by putting them on the Wise Woman's page.

A good place to start is by writing down quotes you like in a separate journal. They don't have to be well-known quotes, just pieces of writing you like. You can use sticky notes to highlight while you are reading, and then go back and gather up the sentences that made your heart beat faster and your head nod in recognition. Write them down, and then use them to make pages of support from the Wise Woman.

Inspiring Quote Examples

I do not feel obliged to believe that the same God who has endowed us with senses, reason, and intellect has intended us to forgo their use.
—Galileo

The unexamined life is not worth living.
—Socrates

Live the questions now. Perhaps then, someday far in the future, you will gradually, without even noticing it, live your way into the answer.
—Rainer Maria Rilke

Darkness cannot drive out darkness; only light can do that. Hate cannot drive out hate; only love can do that.
—Martin Luther King, Jr.

You may never know what results come from your action. But if you do nothing, there will be no result.
—Mahatma Gandhi

A man's work is nothing but this slow trek to rediscover through the detours of art those two or three great and simple images in whose presence his heart first opened.
—Albert Camus

Put your ear down to your soul and listen hard.
—Anne Sexton

Sell your cleverness and buy bewilderment.
—Rumi

Making Paper Sheets From Soy Silk Fiber

The art technique in this chapter is one of the most satisfying techniques I've discovered. Best of all, it can be as easy or as complicated as you would like it to be. Soy silk is a by-product of tofu making, and it is available in white or colors from yarn shops or online. Mulberry fibers—fibers from the papermaking industry—are also available at yarn shops.

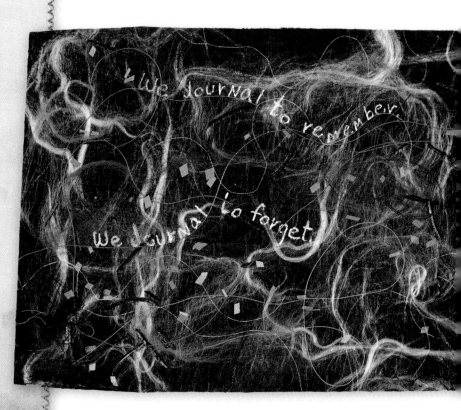

This sheer piece of white silk paper was photographed on a black background to show the silk clearly. Words: We journal to remember. We journal to forget.

find fun bonus content from this book at www.artistsnetwork.com/innerherocreativeartjournal.

83

Soy Silk Paper

These sheets make wonderful abstract pieces, but if you like the layer-on-layer look, use them as backgrounds. Write on them with gel pens, apply collage on them or sew on them. You can also cut the sheets into shapes and use them in other projects.

Experiment by making some sheets with mostly white soy silk and making others with mostly colors. There are endless varieties here.

Substitute a dryer sheet (used for at least four loads of wash) for tulle or netting. The effect is very different—the fiber is more subtle. You can also add snippets of paper or stamped letters with torn edges under the net.

Sheet of silk paper made with green/blue/purple variegated soy silk, mixed with white soy silk and sandwiched on white tulle.

This sheet is backed with black tulle and fronted with blue netting. You can also use a dryer sheet as a backing. You can dye the dryer sheet (with ink or fabric dye) before or after bonding.

1 Place double-sided fusible web on a sheet of black cover stock, covering it completely. There are different weights of fusible webbing, interfacing and one- or two-sided webbing. Experiment to see what does and doesn't work.

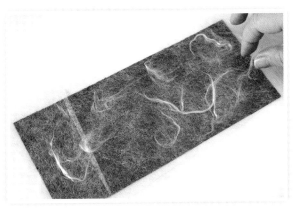

2 Place long and short strands of soy silk or mulberry silk across the page. Work slowly, choosing very fine strands, to get even coverage. Place the strands so they cross each other. They will bond more securely with layers of crossed fibers.

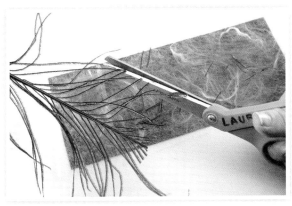

3 Use different colors of strands. Here, the peacock feather fronds left over from another project are cut into small pieces and added.

4 Add finely cut metallic or colorful threads, embroidery threads, Angelina Fiber, ribbon or silk fabric. I had a fabric made of copper fibers and added that, too. You can also build the sheet on different substrates including washi or other natural-fiber papers.

5 If you want to write on the surface of the paper, add a cover of fusible webbing on top of the fibers to give you a surface that will support ink. Cover the entire project with parchment paper. The webbing that extends over the edge of your project will stick to the parchment instead of the iron. Discard the parchment after each sheet.

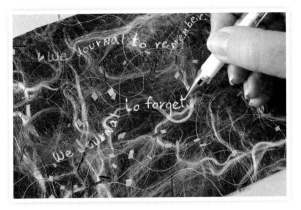

6 Using a contrasting color gel pen, write your quote on the page. You may want to write it on a blank piece of paper to get the spacing right before you write on the fiber page.

find fun bonus content from this book at www.artistsnetwork.com/innerherocreativeartjournal.

85

Collage Combining Drawing With Sheer Fabrics

If you know how to draw, you can combine sheer fabric with sketches. If you don't want to sketch, you can use illustrations from copyright-free books (line drawings work best) or use digital manipulation to create a line drawing look from your own photographs.

Keep your sketch for this technique simple. You want to capture something such as the idea of a cactus, not create a photo-realistic illustration.

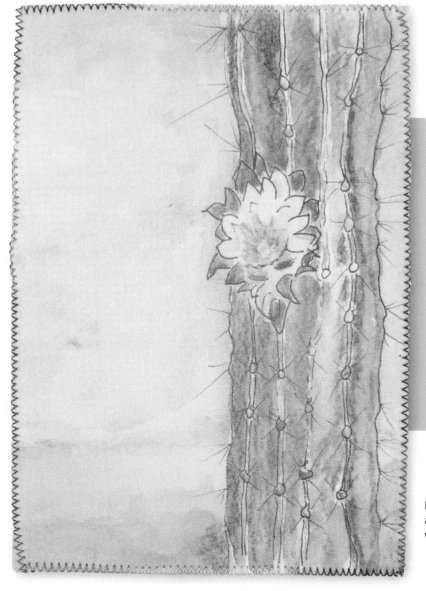

WHAT YOU NEED

5" x 7" (13cm x 18cm) 140-lb. (300gsm) cold-pressed watercolor paper (Strathmore Ready-Cut), several pieces

watercolor pencils

watercolor brush, no. 6 or water pen

black or brown Pitt pens, size S or F

sheer fabric

sewing machine

thread to match fabric

scissors

In this example, I drew a simple sketch of a cactus and added a horizon line of slab rock. I added some color with watercolor pencils.

1 Create a watercolor sketch of your choice, using watercolor pencils, a water pen and a Pitt pen to add final details. (I created a saguaro cactus with a bloom.) Decide if you are going to add a sheer fabric to create a sunset (sheer fabric in orange or red) or night (sheer fabric in dark blue or spangled black), and use colors that work with the fabric color. Keep the background simple to let the fabric do the color work.

2 Attach the sheer fabric over the page using a sewing machine. Make a zigzag stitch around the entire perimeter of the card. When you are finished, trim the excess sheer fabric.

Alternatively, if you don't want to sew your page, place lightweight, double-sided fusible webbing over the entire drawing. The webbing will be visible, but it will simply add a look of fog or mist. (Cover the work with parchment, before ironing it.)

Fabric Tips

- If you find a fabric that you want to play with, buy a quarter yard. The price is easier on your wallet, and you will be able to experiment enough to know if you like the fabric.

- If you know you like the fabric, buy a yard or more. Sheers are often wide, and a yard will last through many pages. Unlike papers, which you can order over and over again, fabrics are seasonal, and often the store will order one bolt. When it's gone, it's gone.

- Experiment with color. Sheers come in varieties with glitter, sequins, interference colors and in different textures. If your favorite color is gone, try something totally different and surprise yourself.

Watercolor Pencil Tip

Some brands of watercolor pencils develop a hard layer—almost like a sealant—and won't write well if they have had the tips soaked with a brush and water. Here's a fix: When you are done using your watercolor pencils, let them dry completely (several hours) and then sharpen them. This removes the "sealant," and you're left with a new pencil surface to sketch with again.

Lines & Stitches

Knowing how to draw isn't a requirement for most of the techniques in this book. If you like to draw, you can always add illustrations, but ideas that use abstract art to create ideas, emotions and meaning free you from the inner critic's evaluation of your perspective or subject matter.

There is also a deep connection to using what is already in your studio. This project depends entirely on color and the motion of stitching to create a sense of calm and transition.

This collage page is made from pieces of paper that carry memories— gift bags, magazine pages, pieces of artwork that weren't used in a project, handmade paper and book pages. It tells a private story the creator alone can remember and understand.

WHAT YOU NEED

paper (or fabric) in one color family, a range of light to dark, several pieces

5" x 7" (13cm x 18cm) 140-lb. (300gsm) cold-pressed watercolor paper (Strathmore Ready-Cut)

sketching paper, 80- or 90-lb. (170gsm or 190gsm), as a base for the strips

scissors

glue or glue stick

thread for sewing machine in coordinating color or a variegated thread

sewing machine

optional: contrasting color for bobbin thread

optional: fusible interfacing for stiffening (if using fabric)

optional: quilter's fabric (goes through a printer and is on paper backing)

paintbrush

pen

1 Choose papers you want to include in your project. Cut the sheets into irregular, wavy pieces using scissors. If you are using book pages, consider cutting them along the length to show random letters rather than readable sentences. You are creating an imaginary landscape and don't want to encourage deciphering visible sentences.

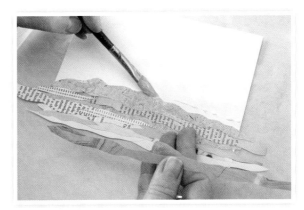

2 Glue the strips onto the watercolor page, overlapping the papers so no background shows through.

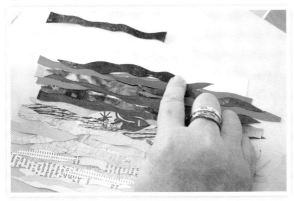

3 To create an imaginary landscape, arrange a dark (mountain) side and a pale (sky or sand) side and glue them in place. Let dry completely before sewing. If the page warps, put it under a weight for a day or two.

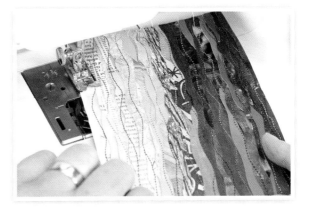

4 Choose a thread that complements rather than matches the papers. A variegated thread works well. You can use a contrasting bobbin thread for an interesting effect. Sew wavy lines along the length of the page. Do not overlap the rows of stitches. You may want to create a layer of stitches the same shape as the pieces you cut and pasted down.

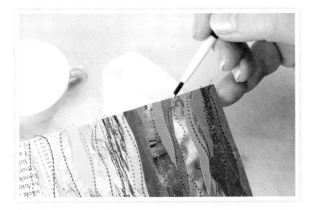

5 Glue the top and bottom threads to the edge by touching a brush loaded with glue at the beginning and end of each row of stitching. Trim the threads so no loose ends show.

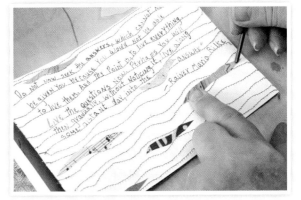

6 Use the wavy stitching lines as guidelines for your writing. Color in some of the spaces to coordinate the back and the front. Try using different styles of hand lettering for interesting effects.

find fun bonus content from this book at www.artistsnetwork.com/innerherocreativeartjournal.

89

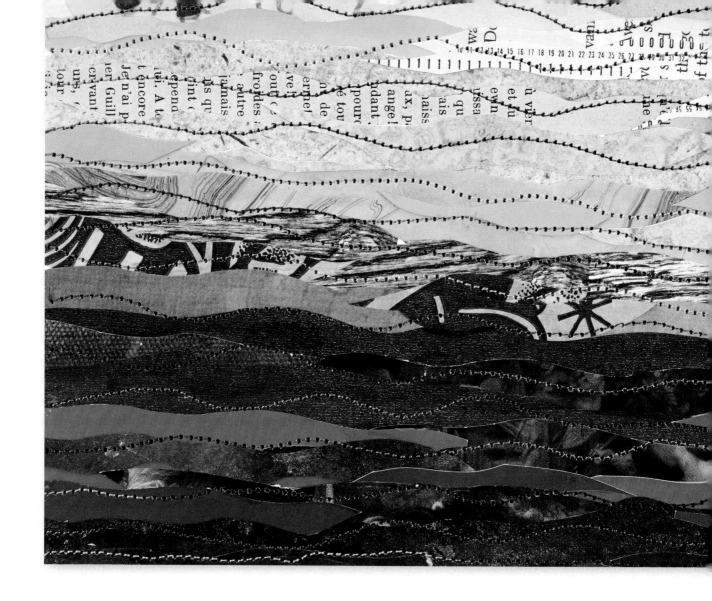

If you are cutting fabric, use a rotary cutter to create the wavy pieces, cutting in the direction you are most comfortable using. The lines can be gently wavy or more distinctly wavy. For this piece, the gentle waves will overlap better, but you can easily mix the widths or overlap them to keep the background from showing.

Your imaginary landscapes can be any color and represent your world as you experience it. If you are going to create your collage on a separate sheet and glue it onto your freestanding page, you can cross some of your stitching lines, as you won't be writing on them when you create the back of the page.

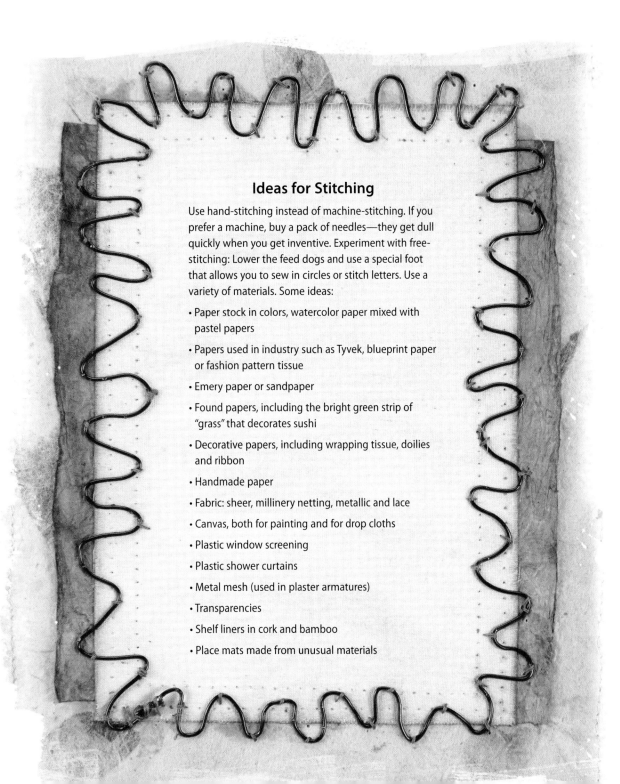

Ideas for Stitching

Use hand-stitching instead of machine-stitching. If you prefer a machine, buy a pack of needles—they get dull quickly when you get inventive. Experiment with free-stitching: Lower the feed dogs and use a special foot that allows you to sew in circles or stitch letters. Use a variety of materials. Some ideas:

- Paper stock in colors, watercolor paper mixed with pastel papers
- Papers used in industry such as Tyvek, blueprint paper or fashion pattern tissue
- Emery paper or sandpaper
- Found papers, including the bright green strip of "grass" that decorates sushi
- Decorative papers, including wrapping tissue, doilies and ribbon
- Handmade paper
- Fabric: sheer, millinery netting, metallic and lace
- Canvas, both for painting and for drop cloths
- Plastic window screening
- Plastic shower curtains
- Metal mesh (used in plaster armatures)
- Transparencies
- Shelf liners in cork and bamboo
- Place mats made from unusual materials

The Wise Woman's Writing Technique: Revisiting Wise Words

Words: "Do not now seek the answers, which cannot now be given you because you would not be able to live them. And the point is, to live everything. Live the questions now. Perhaps you will then gradually, without noticing it, live along some distant day, into the answer."
—Rainer Maria Rilke

Journaling has many results. It can help you think through a problem or develop an idea. It can help you choose from a number of good ideas; it can help you heal. You write down your heart and feed your soul. Some of the words you write will comfort or inspire you long after you have written them. They are the words of your inner hero, and they can be lifted out of the journal and put on the back of your inner-hero pages. Your own words are filled with wisdom; don't leave them buried in a journal from years ago.

If you've been keeping journals throughout your life—consistently or not—it's time to revisit these treasures for the Wise Woman's words of advice. Go through your journals, and when you find a phrase that speaks to you, write it down. You can keep a quote journal, or you can store them on your computer. Traci Paxton Johnson, who did the artwork at the beginning of the Gardener chapter, keeps quotes indexed by topic: Acceptance, Accomplishments, Aging, Ambition, Art, Attitude, Balance, Be, Beauty, Beginnings, Believe, Blessings, Challenges, Change, Character, Choices, Compassion, Courage, Creativity, Direction, Discovery and on through the alphabet. I once made a Scribe page using just her topic titles. The topics aren't on a spreadsheet; they are just in alphabetical order in a document.

You may think this is fussy until you have accumulated a dozen pages of quotes and know you saw the one you want on one of those pages but can't remember which one.

Cross-reference your quotes by putting the same quote under different categories. Your changing emotions will recall different words or references in the quote, and cross-referencing will make the right quote easier to find.

Using the Wisdom of Others

You'll also find great quotes by other people, not just reposted on Facebook, but in the articles you read, in books and magazines, and listening to other people. I'm a fan of audio books for my morning walking meditation, and sometimes a sentence is so powerful, it makes me stop walking. I have a message-notes app on my phone, and I'll record the sentence along with the book title and author so I can add it to my list later.

Always keep track of who said or wrote the quote. Write the name down as the author until you do a bit of research. Along with the quote and author's name, keep the name of the book, article, magazine or blog where you found it.

Why is it important to know who said the quote? Lots of reasons. Attribution is important: You want to know who said that brilliant sentence, and you want to let other people know. Smart quotes lead you to good books and interesting thoughts. If you liked what someone said, you might want to read the whole article from which it was taken. Attributing your quotes to the people who said them, even if it was your friend (or you!), reminds you of the time and place you heard it, too.

Quotes make the most of every word. A short quote can go a long way to help you solve a problem or pull up your socks and get back to work. Finding a quote that speaks to you is a treasure, but sometimes you derive several meanings from one quote, depending upon the emotional place you are in when you read it or reflect on it.

For example, the Bohemian-Austrian poet Rainer Maria Rilke wrote:

"Let everything happen to you
Beauty and terror
Just keep going
No feeling is final"

You might want to think about that quote in light of what you have gone through in relationships, in creating difficult pieces, in working through fears to overcome them. You might also be caught up in the idea that no feeling is final—that you can have many emotions about events or people, that you can feel contentment about a decision you made one day and anger the next.

A choice of meanings is a good thing. You can use the quote several different times on different pages, each time creating a different meaning and a different piece of wise advice.

Putting Words in Your Inner Hero's Mouth

Now that you've had some time to explore quotes of your own as well as from others, it's time to give this chapter's writing technique a try.

Before You Start:

Write a quote you like on a fresh journal page. Underneath it, write two different pieces of wisdom you gleaned from the quote. This can be an inspiration or a lesson. In the Rilke quote, for example, you might write these different interpretations:

• Don't avoid emotional pain; it has a lesson to teach.
• Look at beauty carefully and do more than admire it. What lesson does it have to teach?
• What emotion would I like to reconsider?

Wise Advice to Yourself

Use the freewriting technique in the Scribe & Free Writing chapter to freewrite about these questions. You will be surprised where your heart takes you and what you discover about yourself. Underline the sentences that bring powerful reactions from you. The reaction can be emotional, thoughtful or profound. Rewrite it as a piece of advice for yourself and then write that piece of advice on the back of your Wise Woman journal page.

It's a good idea to let ideas go speeding past. It helps develop discernment.
-QUINN McDONALD

Breaking the Rules

This book divides chapters into art techniques and writing techniques, but the various inner-hero voices you develop will jump far beyond what you acquire in this book. Your self-created inner heroes and their voices are uniquely yours. They help you face your very personal inner critic. Make up your own combinations or rules—if your inner Cheerleader wants to speak through counted cross-stitch, do it. Combining techniques is the whole idea behind the freedom of mixed media. You are making meaning, not following instructions.

Your loose-leaf pages are yours. They don't come from a kit; they don't have to look like a sample. Use your own handwriting. Sure, you can use stick-on letters or machine embroidery. But I like to see my own flawed, far-from-Palmer-method scrawl. It reminds me that I am imperfect and just fine in this moment. Listen to your inner hero; don't stop creating to struggle with the inner critic.

Quotes on the Front of Your Journal Pages

While most of this book has encouraged art on the front and words on the back of your inner-hero journal cards, feel free to listen to your own heart. You might want to put a quote on the front and artwork and the meaning on the back. You could make a series of cards to help you think through layers of a quote and what you discover about yourself over time. (That's a great idea!)

Creating a series of pages that can be used as a group or individually (see the next chapter for suggestions) will help you tackle your inner critic when he shows up at different stages of a project's development.

You might find that the writing you did about leaning into your discomfort is useful at the stage when you first incubate a creative project. You might decide the idea about beauty Rilke wrote about is useful in making decisions about what to include and what to leave out of a project. Finally, the idea of no emotion being final can bring peace if you struggle with project completion. A short quote can cover the entire creative project, so it's easy to see why it can deserve equal face time.

Using digital tools, I isolated one of the vessels and created different sizes on different papers—some matte, some shiny. I had begun to wonder how much the vessels held and how heavy they were to carry. But no matter what the size, once a vessel is full, it can't hold more. So on the back of this one I wrote, "The size of your imagination is limited by what contains it. Choose carefully." I liked the image, so I created another one, and the back of it said, "Your heart is filled by what you choose to think about. Hate and love take up the same amount of space, but poured out, they have different results."

I used the photo and first printed it out on cream-colored cotton fabric. Those vessels contained water and grain to keep people alive. Now they contain shadow and light as they sit in the ruins of the granary. Here is what I wrote on the back of the page: "Everything has a story to tell, don't judge yesterday's actions by today's culture. Listen to the wisdom of the time."

Same Artwork, Different Ideas

Here's an example of several pages made from one photograph. I asked photographer Bo Mackison if I could use one of her photos and alter it. It's important to ask because altering is something some photographers wouldn't want you to do to their photograph. It's their vision, and you are borrowing it. Luckily, Bo said yes.

Her photo was of a series of grain vessels preserved from the Tohono O'odham tribe's granary while they lived in what is now a national park south of Tucson, Arizona.

Each of these pages has a very different meaning, and I used just one photo to create a variety of emotions. Allow yourself to play with techniques and with heroes. They have many things to say to you—and to your inner critic.

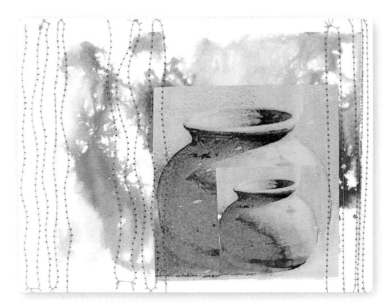

In this page I used two overlapping pots and combined the ink technique with sewing and collage. On the back of it I wrote, "If you have just one vessel, you don't know how big it is. You just know what you use it for."

Don't Limit Yourself.

Here are some final thoughts for your cards. Cut through your old ideas about what may be included in mixed media.

More Alternative Ideas

• Create animal totem pages as your inner hero pages—especially if you are close to one or more particular animals.

• Use found items that you like or are meaningful; for example, if you find a buckle, it can symbolize opening, holding, adjusting. And it can be used on the front or the back. Because these pages are all loose, they can be dimensional because there is no one binding that holds all the pages. Freedom!

• Some interesting additions with meaning for you might be pieces of mica, mirrors or foil, as well as techniques like cutting doors or windows out of the page to connect front and back.

• Keep a recording device handy. An app on your phone is good, but there are also inexpensive recording devices for memos. Record your thoughts as you are working. Your inner critic shows up while you work? Take notes. Then call on your inner hero and record what she might say while you are working.

• Be deliberately messy and fast in your handwriting. It's very freeing, particularly if you are using a bright orange or lime-green pen. You can't be angry when writing with a pink pen. Sparkly gel pens make any handwriting look decorative. But write more slowly with a gel pen to get better (non-skip) results.

• Sew wavy lines on the front of the page and let them show through the back. Then use the wavy lines on the back as writing guidelines.

• Create the same ideas in two different colors—white and black, for example—and see what ideas you have about the changing meaning when the color changes.

White or near-white squares cut out of fabric and paper, stacked and hand-stitched onto the page with white pearl cotton.

Squares of black-on-white or black paper or fabric cut out, and hand-stitched with black pearl cotton onto a black background, then sprayed with pearlized ink.

Creating a Background for the Wise Woman Page's Journaling Side

If you create a collage with stitching on a separate page, and then glue it to the freestanding page, you will have a clean, plain back to work on. You are going to be writing a quote on the page, so you won't want a lot of color, and you won't want a big buildup of papers. Here are some ideas to test on a plain piece of paper until you have the technique worked out.

1. Use a dye-based (water-soluble) stamp pad, brush it across the surface, and then brush a damp sponge or mop brush across the page, spreading the color.

2. Print out a photo you like on your ink-jet printer. Spritz the back of the page with water and lay the printed sheet, image side down, on the damp paper. Some of the image will transfer but not all. Use a damp sponge to blur the image and spread the ink to create a background. You are doing this for color, not for crisp image transfer.

3. Spray diluted or pale ink on a dry brush and brush across the page, leaving interesting streaks on the paper.

4. Use dye markers, not alcohol. This is the method shown below. Tim Holtz Distress markers and Tombow ABT will both work, but in different ways.

Test a marker on a plain piece of paper by rubbing it, using the brush end, over an area of about 1" (3cm). Wet the mop brush and rub gently across the color block. If the color floats into the water, spread the color over a section of the page. (Colors dry lighter.)

If the wet brush over the test color block does not spread ink over the page, rub the marker on parchment paper, quickly add water using the mop brush, then transfer the color to the page. Do not rub a marker directly on a wet page. It won't transfer color and it may make the marker color lighter for the next few uses.

In this technique, less is more. Keep the colors pale. Let the page dry completely before doing anything else.

1 Draw wavy guidelines with a soft pencil. Print the quote with a pencil first, and then proofread to make sure you spelled everything correctly and added the right punctuation. Once you are happy with the quote and attribution placement, ink over the letters using a waterproof marker, like a Pitt pen. Allow to dry.

2 Erase stray marks after the piece is completely dry.

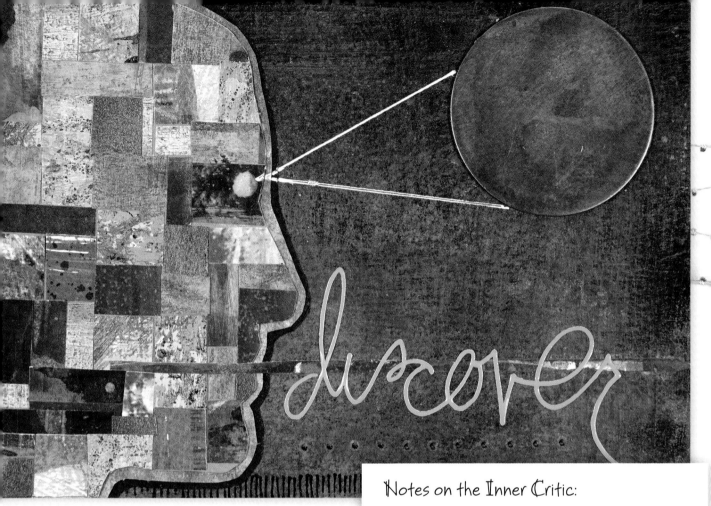

Words: Letting go and leaving it up to the power within is all one needs to do to create magic within.

Notes on the Inner Critic:

"My artwork, titled **Discover Within**, is all about the distinction between my inner critic, who arises from the outside, and my inner hero, who comes from the inside. As in everything in life, my ultimate goal is balance, in this case between my critic and my hero.

"My inner critic is the fear that others will not like or understand my work, that an art piece will not evoke a response—be it positive or negative—and that an artwork will not sell. I know that when I let a piece of myself out into the world, it (and therefore I) will be judged. And I know that I do not always pass the test.

"My inner hero is the voice that acknowledges my creativity. It is the confidence in my ability and the knowledge that as long as I am content with what I create, it does not matter what others think. It is my strong sense of self, which in turn provides me with the stability and security to step outside my comfort zone, artwise and otherwise.

"I am learning that my inner critic is not all bad. Once I can get past the initial sting, there is much to be gained from embracing the critic. First, it gives me back the power and control and reduces my fear. Second, it guides me to be better. I can recall no time when listening to my inner critic didn't take my artwork to a new level. And that always makes my inner hero sing."

—Seth Apter

BRINGING YOUR INNER HEROES INTO YOUR LIFE

Most of the other journals you've started or filled wind up back on the shelf, but this collection of journal pages will be one you can use every day. The more you use it, the more pages you make. The more pages you make, the more you explore your life, the more you listen to your inner hero. And the more you listen to your inner hero, the more your inner critic is trimmed down to size. And that, as you know, is an excellent thing.

The journal pages you make can be used in many different ways: to give you insight into your meaning-making, to explore your art and allow you to work deeply, to help you brainstorm ideas.

You can also use your journal pages with groups: as part of artists' date discussions, to invite people to help you brainstorm an idea you have but feel unsure about or to know what to choose to start (or quit) next. You can even use pages to create discussions about ideas and other people's inner heroes. If you've ever been in a book club in which people haven't read the book and are looking for a way out, this may be it. No one gets bored talking about their conversations with their inner heroes or their insights into working with their inner critics.

The whole purpose of this book is not to get you to journal every day, but to give yourself permission to make meaning every day. When you play and relax, meaning comes and sits in your lap.

While it doesn't matter if you make the art side first or the word side first, here are suggestions for each direction.

In this section, I use the words *pages* and *cards* interchangeably because the pages are made on watercolor paper and look like large cards.

Start With the Words

Make a card by first choosing an inner hero and then creating the writing portion first.

Begin by writing not on the card but in a separate journal or on a piece of paper. Write a dialog between you and your inner hero.

Start with what the inner critic said.

Start a new line and write down how much of that is true and how much of that is habitual—something you say to yourself all the time and believe.

Start a new line and step into the persona of your inner hero and write what the inner hero would say. It's not going to be gooey platitudes; it's going to be fierce. Embrace it!

Start a new line and put down what you would say—agree, add to it, argue.

Continue this way until you have some rich insights into your creative struggle.

Choose a powerful sentence in that dialogue, and put it aside to use as the text portion on the card. Much of your work on these pages is a deep emotional connection to your creativity.

Spend some time developing the backgrounds for both the art side and the word side. Wait until you are satisfied that both sides combine for a good visual and emotional fit.

Then go on to select and develop the art part, letting the words inform your color choice, technique and texture.

Start With the Art

You may discover that it is easier to express yourself in color and artwork first. Choose your inner hero and a technique that expresses the strength of that vision and your own. Much of this discovery is play. Yes, play. Feel free to play until you have something you like. (That chicken was a way for me to work out being braver than I felt. And it allowed me to laugh at myself and be creative in thinking of a solution.) When it's complete, think back on your play and discover what this piece says to you.

Write down what you thought or heard from your inner hero when you were playing. (Do not confuse this with your inner critic, who may have said something snarky while you were playing, including that you need to get to work.) It can be a lot or a little. What is important is that it will trigger your joy in playing as well as more wisdom about your creativity. Now you have the words. Decorate the back to suit yourself, not what you think you should do.

find fun bonus content from this book at www.artistsnetwork.com/innerherocreativeartjournal.

101

Using a Single Card in a Special Way

A single card can hold a lot of powerful meaning for you. A single card is often an easy way to work a lot of meaning into a single day. Here are some ideas for focusing on a single inner-hero card.

Dream Cards

Choose a finished page. Look at the front and back while you consider the meanings of your creative work. What would you like it to mean in your future? Once you have the right page for that day, put the page under your pillow (another good reason to like the freestanding cards). After you wake up and before you move, check in on your dreams.

It may take a few days to hold onto a dream long enough to remember it. If you take medication to sleep or to reduce anxiety, it may take more than a few days. What is important is that you capture any detail that you remember from your dream. You don't need to look up meanings in dream books. You can untangle the meaning of your own dreams. Think about metaphor: What does your dream mean in terms of important events in your life? What does your dream ask of you? What does it promise you? Is there some action that seems important to you? Write down everything you remember before you get out of bed. It will fade fast, no matter how vivid it is now.

If you don't understand what your dream means, it's not surprising. It can take a whole series of dreams until the meaning becomes clear. Meanwhile, use another card and dream with it. You will dream about more pieces until you have the answer.

Meditation Card

Sitting in silence to meditate is not always easy. You might need a middle step. Take one of your pages and think about the inner hero the page represents. Keep your inner hero in mind and think about what you need to talk about. Have a conversation with your inner hero while you sit in silence. Then spend a few minutes journaling about what you've learned or what you've thought. This focus is a good way to start a meditation practice.

The moon is smaller than the earth. Less gravity.

And yet,

the moon pulls at the oceans, creates tides.

Words: The moon is smaller than the earth. Less gravity. And yet, the moon pulls at the oceans, creates tides.

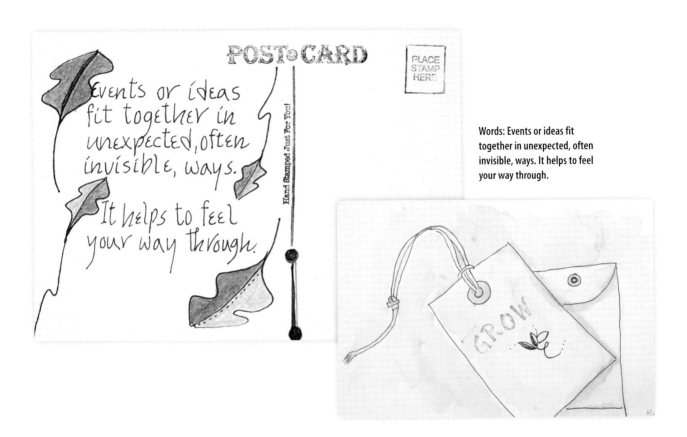

POST CARD

Hand Stamped Just For You!

PLACE STAMP HERE

Events or ideas fit together in unexpected, often invisible, ways.

It helps to feel your way through.

Words: Events or ideas fit together in unexpected, often invisible, ways. It helps to feel your way through.

GROW

Thought for the Day

Pick a card early in the morning; this is your card for the day. Decide what idea in the card you want to pay attention to. What wisdom does your inner hero have for you? You might want to take the page to work with you as a reminder of your strength and intentions for the day. Throughout the day, pay attention to how often and in what different ways the card's meaning shows up.

When you get home, journal about your experience. You'll be surprised how often you look for your idea because the card is a reminder to keep yourself open and vulnerable. You might also be surprised at how you avoided thinking about positive ideas. Work can sometimes push your buttons and allow you to get negative.

Allow Yourself to Heal

If you experience anxiety and anger about events in your past, create a Healer card and think how that card can help you move away from your anger. Maybe it will help you to realize that you can't keep everyone happy. Maybe you will find strength in your conviction and balance it with your need to please everyone you meet. Or perhaps your Healer will inspire you to look for ways to let go of

anger that is not serving you. This is not "getting over it" or "finding closure." With deep anger at injustice, there is no closure. But art can help you move through your anger instead of running headfirst into it every day.

Anger and fear can also be powerful fuels for your art. Use the emotions you feel to create. Create in anger, create in fear, create in happiness, sadness and confusion. But create. Then look at what happened to your emotions and what you gained from your own creativity.

Send Yourself a Postcard

The pages you make on watercolor paper make excellent postcards to yourself. Using the instructions in the writing half of the Wise Woman chapter, create several postcards. Drop them in the postbox and forget about them. The emotions you feel when you get your mail are more likely about bills or junk mail, so you may not recognize the postcard when it arrives. Take some time to read it and think about the message—what happened today that makes this postcard special or meaningful?

If the postcard is scuffed or ripped, it just adds character to your page.

find fun bonus content from this book at www.artistsnetwork.com/innerherocreativeartjournal.

103

Using More Than One Card at a Time

In the same way you can work on more than one page at a time, you can also use more than one page at a time. By looking at two, three or more cards, you can find common themes, reactions, emotions and solutions. You can compare how you felt about the same reaction at different times. You can see your own changes and growth over time. You can even see the evolution of your inner heroes.

You'll never run out of ideas for these cards, and you will never be done with delighting in the different results you get when using them to inspire your own creativity.

Where Are You Today?

Choose three cards and put them in front of you, image side up. The first image represents your past. Read the message on the back and think of an event in your past that would have been helped by this writing. How could that event have ended differently if you had taken steps with this advice? What meaning does the card hold for today? How did you react differently in the past? How have you changed?

The second card speaks to your present. What is important for you to know about today? What actions can you take to be more sure of yourself or to learn something important? Write down your thoughts in a journal. You might want to have a writing journal as part of your journal collection. Not every journal has to be an art journal. You learn more about yourself and your journey every day.

The third card is the future. What do you want for yourself? Does it seem impossible? Have a slow conversation with the inner hero on your future card. What does the inner hero have to say about moving into your future? What will you have to change? What should you take with you? What will you have to give up or put down? Your answers may be fodder for more pages. Your future starts in your hands. Let your inner hero hold your hand and walk with you.

Directions From a Compass

Put down four cards, one for each direction of the compass. Each card represents a choice you have, a different direction to choose and different actions to take. Think of a problem you are having, one that is causing you heartburn because you don't have a good decision, direction or answer. Read the words on the card on top (the north card). This is a *start-in-any-direction-but-start* card. Think of your choices and see if this card encourages a solution or an action. Don't rush out and take this action, but use this card to help you clarify your choices.

Move on to the card on the right (the east card). This is the *begin* card. See what the words or art indicate as a good beginning point. Often the direction we take depends on how we are facing when we take the first step. Consider your options.

The south card is the *unexpected-answer* card. What does your inner hero suggest that is unusual or out of your comfort zone? Who would you have to be to take that as a starting point? Does any of it appeal to you?

The final card—the west card—is the *end of your journey*. Read the wisdom of your inner hero and think about the best outcome—the one you would choose if you had endless energy, resources and time. Give yourself some time to enjoy this happy ending. What would your life look like if you could make this happen? What would be your first step?

After considering all the cards, you have pros and cons for different choices. Spend some time freewriting in your journal about these directions. Your choice will become clear to you.

Using Cards With Friends

You can use your cards with friends. Sharing pages and meanings is a good way to hear other people's ideas and get a creative boost along the way. I call these meetings "Ignite a Spark Groups" because anyone can spark a brilliant idea by listening to someone else's idea.

Discussion Group

Use your card to create an Artists' Date (the term used by Julia Cameron in *The Artist's Way*) with some creative people you know. You don't have to know them well; that's what the pages are for. Everyone sits around a table. One person has a watch or timer.

Each person gets five minutes to talk about one of the self-made cards. You can talk about what it means, explain why you linked the words to the technique or ask for help in adding meaning. After the five minutes are over, each person around the table gets one minute to speak.

You can change the times or add rules, such as "No fixing or giving advice unless specifically asked."

This exercise creates a very intense experience for the speaker and brings a closeness to the whole group.

Brainstorming With Others

We often brainstorm on our own, but brainstorming with others brings you ideas you haven't had or opens a door in a new direction. Put down your card in the middle of the table and say, "I would like ideas on" Don't add what you don't want to hear or what won't work.

Everyone else at the table (one at a time) contributes ideas. The person who asked for help writes down all answers, whether or not they seem practical, easy or helpful.

Ideas that seem strange or unhelpful, when written down and given time to develop, may shift shape overnight or lead to new ideas and new cards to make.

After everyone has had a turn speaking and listening, everyone spends some time journaling within the group, writing down ideas and thoughts for other pages based on what they heard. The pages you make don't have to be based on just the help you got but may be sparked by a conversation with another person.

My Page, My Problem

Everyone in the discussion group brings a card they have made about a problem they have. The group agrees to the limits of the problems brought—creative problems, personal problems, project problems.

The first person puts down a card in the center and has five minutes to explain the problem and what they have done about the problem so far. The speaker then asks for a specific type of answer:

- To hear from people who have faced this problem and hear what they did and what the result was.
- To hear from everyone what the next step should be.
- To hear any and all wild ideas that would fix the problem in three days.

The rest of the group contributes only those suggestions asked for. Each person must craft an answer that can be given in a set time (e.g., everyone gets one minute).

The person who put down the card listens and asks questions to clarify the answer but does not criticize or reject any answer.

Everyone is encouraged to take notes or write down phrases that spark invention, solutions or more cards.

After the circle is completed, the group spends time journaling individually. Another round may take place if people want to read their journal entries.

And Then I Thought . . .

Any group activity suggested here can continue to more than one session. People in the group can agree to come back in a certain amount of time and show the additional cards they have made after that session.

Share Making Cards

Of course, you can get together and *make cards* as a group activity. Extroverts will think this is a great idea; introverts will have trouble imagining why having other people around when making these private cards is reasonable, much less a great idea. No matter. If it seems like fun, try it. Get together, each person bringing art supplies plus something to share in a Share Pile in the middle of the table. The group can decide to work in silence or to have a discussion while working. When you use the items in the Share Pile, you will discover other ideas or solutions.

Share your cards afterward. If you are bold, make cards for other people at the table and exchange cards. (Make sure each person winds up with a card.)

Group Postcards

Instead of making postcards just for yourself, try doing it for others. If you don't know each other well, you can use a postcard icebreaker to start. Everyone brings two used paperbacks. Romance and adventure paperbacks work really well for this.

Using a craft knife, trim the front and back covers off the books. Trim the corners so they are round and look like antique postcards. Put the covers in a box. Everyone draws a cover at random. Some people will wind up with front covers, some with back. There will be more covers than people, as each person brought two books. In case one cover doesn't work for anyone at the table, another cover can be drawn.

Read the cover information (back covers often have reviews in praise of the book, front covers have images).

Paint over any words on the inside of the cover; that will be your message side. Leave the printed outside of the book the way it is.

Use a rubber stamp or draw a line on the back and add the word *Postcard* to create a postcard look and divide the back of the cover into an address side and a writing side.

While you are waiting for the paint or ink to dry, each person holds up their book cover and explains what kind of person should receive that book cover. Whoever wants to receive that card takes it and writes their mailing address on it while the next cover is being read. When all covers have been claimed, pass the covers to the right. No person should now have a card with their own address on it. Using the information on the cover, write something positive or funny on the card, put a stamp on it, and return it to the person who is the "mail carrier" for the night. That person will mail all the cards before noon the next day.

Using Cards for Healing

Art heals. It doesn't do it overnight, and it doesn't always do it on your schedule, but there is no doubt that emotional pain, anger and frozen spirits can be healed through creative work.

David Dawangyumptewa: Inspiration Through Anger, Loss and Struggle

David Dawangyumptewa's last name is the Hopi word for the motion of the sun as it appears on the eastern horizon. And following the light of his journey has been a lifetime of twists and reminders that he is not in control of his life. David is connected to the Hopi Water Clan of northeast Arizona. His early detailed work focused on water images: frogs, dragonflies, colors of the water. It almost always contained figures interacting with animals.

Then he had a stroke. Not a mild warning stroke, but one that sent him into a coma and damaged his right side. He could not hold a brush, a pen or a pencil. His thoughts were not clear or sharp. But David survived his coma. He woke up to the burning, clear realization that all he wanted was his old life back and the certain knowledge that his life would never be the same. He began to work on putting together the same life he had, but despite his best efforts, his old life was gone. It had vanished with the stroke. The more he told people he was going to put his old life back together, the more people agreed it was what he should do, and the further away the goal slipped.

Here is the part of David's story that amazes me: He decided that he was still an artist but a different artist. And after being right-handed all his life, he picked up his pen in his left hand and began to teach himself how to do his careful, detailed, precise art with his left hand.

David agreed to contribute to the book with both an interview and his artwork. His powerful words inspire anyone who has struggled to gain or regain meaning-making through art.

Q: Your art shows a powerful vision of Hopi myth and culture. How did you develop the idea of this abstract art that is still so powerful?

David: Time and time again, my visions of design and development had been trial and error. My sense of design came at a time in my life that I realized that my thoughts are different from those that have been around me. My abstract vision started from one element to another. I am a naïve artist that has no formal training except that I enjoyed what I did see and the colors that played off of each other. At first, I was afraid of ridicule and judgment and in some cases, I do doubt myself. For the longest time, I did not share any of my dreams, thoughts or emotions. Strong Hopi subject matter came from my uncles and a brother-in-law. The calm, solace emotion was sweet, kind and approachable. Growing up, my mother had a great alto voice and my father was a jack of all trades. They were respected far and near.

Q: After your stroke, you taught yourself to paint with your nondominant hand. Your inner critic must have told you many times that this was a bad idea. What kept you going during the long task of relearning?

David: To continue to paint or design with my nondominant hand was important because that was all I had. My disgust is that my right hand is no more. And if it is there, too much time would be required to regain that fluidness. I know that if I continue to train my right hand, part of me will return. So the left hand was left. The need to create was there, but the way to create funds was a real necessity. It had to be done. Although I did have other talents, I didn't think that it was marketable, and the best venue was to pursue what I already knew. Color and design is my strong asset. To convey that emotion to the viewer would be my gladness.

"Exploding Moisture" original art by David Dawangyumptewa

Q: Did you feel like giving up and quitting?

David: I don't think that was an issue. It needed to be approached. Of course, I was angry for what had happened. Then when I realized what I had left to work with, it was my thought that I needed to do something better, fresh, new and positive. Yes, the brushes were there, the pencils and paper were there. They sat for a long time, alone.

My flat file had images waiting to be worked on. The paper laid nearby, and the tubes of paint did not move. There was a period that I was not going to be anything. I was madder at myself than anyone imagined. I was always self-contained. I wouldn't ask for help or things. My independence was important and with that in mind, I didn't

want to be in a position to be in debt of anything or to anyone. Yes, there are times when I do want to leave my goals, only to realize that is all I have. Still, I get those feelings. The anxiety and depression is still a common hurdle that comes too, different times of the year. Sometimes, a tone in a voice, a chance that I did not grasp or a disappointment that I couldn't achieve what I wanted to opens that door of dissatisfaction. It does still happen.

Q: What did you do or say to yourself to learn not only art but the detail of your art?

David: Basically, I wanted to come back better, fresher and do what I have not done before. Because of my new challenge, I had to learn again how to hold a pencil, a brush and

find fun bonus content from this book at www.artistsnetwork.com/innerherocreativeartjournal.

109

the difficulty of opening a paint tube with my fingers, let alone with my teeth. At a much slower pace of concentration, little by little, I learned the motions of my left hand. Still impatient with myself, I kept that emotion to myself. I became more isolated from family, friends, past associations and those who were concerned for me. The detail and depth of images became my escape from myself. I want to go even further to this day.

Q: The inner critic generally shows up while we are working and says things such as, "You aren't as good as you think," "No one will understand this, much less like it." Inner critics generally bring thoughts of lack (not good enough) and attack (someone else will steal our ideas). What specifically do you wrestle with?

David: Exactly. The surprise and disappointment to who I thought was with me when they actually weren't. I am not going to be as good as I had been. As if I put myself on some sort of pedestal. At the time, I was involved with many projects. I knew many Native artists from all over the country. I had good relations with all I had known. I was involved with putting up projects, events and gatherings of other artists. When this happened to me, the history of my involvement was taken from me in a moment.

Of course, I am my greatest critic. I still am. Still, I see what I have done before; I still see areas in an image that I can do again, improve on or start over. Yes, I do want so much more. Of course, the doubt will be my challenge. The limited mobility is a large factor. I can physically walk and get around, but my assertiveness seems to be lagging often. I want to continue to address that. Yes, this was a lesson of surprise and disappointment of who was actually by me. And the extreme was, there were so many more that took their place.

The blessing was that many knew of my crisis. Then there was the feeling that I realized that many let me into the darker and deeper doors of their heart and shared their stories. That was that honor that I possessed. They trusted me. It made the hurt not so sharp.

Q: Do you have a ritual to start a new piece, a routine that includes praying, planning, sketching ideas or drinking coffee, or some other step that you take to begin working?

David: In the morning, feeling grateful for another day to challenge my shortcomings, I feel glad for another day of testing. I don't think I have a ritual. I think of a curved line, a placement of lines or a color that blends well. In the past, I would start with a maiden figure and create the environs around her. Now, I hope to create a piece that is moving within itself. I want to create something that will stand apart from the masses. My start can be silence or music in the background. Contemplating of thoughts, ideas come to mind that I had previously, or an anger motion of a swipe of the pencil starts the emotion. Still, currently, I know that I have so much to discover. That is anger within me as well. My challenge is me. Of course, when I see something that is satisfying, I feel gratitude. Then push ahead. Maybe that in itself is a ritual.

Q: You have had many hardships to overcome, including your recent ankle fracture that will keep you out of school. It would be easy to give up. What keeps you going?

David: I worked and pushed myself to be ready for the classes that I am taking. My goal was accomplished. I am back in class. Leaving the physical therapy facility, going back into the real world was strange. Again, persistence is important. I have no one to depend on for everyday tasks, and my realization is that I had to do it myself. While I was in therapy, there was a beginning of reacquainting myself with family relations and beginning to realize that there are those who want to help and to be by me. After my crisis therapy—both mental and physical—I realized my limits and hardships. This was when I needed to look farther than my surroundings. The field of digital programs came into knowledge. This door made me realize that I can create in more than one medium. To push my original ideas further, there is another life inside the previous one. I think that I needed to get out of my comfortable zone and to learn new directions. Perhaps renew ideas that I experimented with in the past. It is important to evolve. Native America is an evolving culture and will continue to be.

Words: Seriously corny. Antithetical. Untouchable noise. Visions 4 sight. And. Both Admit infinite trinities. The Synthesist moved moves. —Liz Crain

Notes on the Inner Critic:

"Once I determined my inner heroine was The Synthesist—loosely defined by me as 'She who embraces and combines seemingly disparate perceptions, processes and materials'—I figured the only way to make a piece of art expressing her importance would be to live it.

"That also meant I had to rouse my inner critic, but how? I dawdled, I sidetracked, I choked. I had no ideas. I felt the deadline breathing heavily, my fears of missing out looming. At the same time, I noticed my Synthesist remained curious and sweetly upbeat, nodding her head.

"Heartened, I decided to take my inner creative pantheon to the deep end, via the rapids. I committed to working blindly in an appealing but utterly unfamiliar new method to give them all the opportunity to bust out their best moves.

"This piece demanded nearly all my 2-D and 3-D skills. I painted the original raw clay slab with ceramic colorants, drew, cut it apart, rearranged the pieces, turned some over, rolled them back together, stretched, layered, shaped, cut to size and textured it. After firing, I enhanced and wrote on it with ink pens and colored pencils. I made a dozen different pieces to get this one. Through its very being it encapsulates the ongoing conversations of my creative process.

"Decades ago, I read an interview with Maya Angelou. In the interview, she said something like, 'Human beings aren't either-or. We are and-and-and-and.' That's The Synthesist in action! I think I'll call her Maya."

—Liz Crain

STORING & CARRYING YOUR PAGES

Most of your journals are books or spiral bound. They may have lines or be unlined. You have your favorite brands. You fill them up or leave a few pages blank at the end. And they end up on a shelf. You can stack them neatly or put them in rows, but they generally sit on the shelf. And yes, I have rows of bound-book journals. I love them, too, but for the flexibility of mixed media, loose pages have a big appeal.

One advantage to loose-leaf pages is that you can rearrange the cards to your heart's content. If you want to sort them by date, all you need to do is date each page. You can sort by emotion, by color, by inner hero. In fact, sorting is an important part of using your new journal.

Make a pretty holder, and you will have all your pages together in one place. (There is a deep-felt need that pages be together.)

So how will you hold your pages together? How will you store your mixed-media inner hero cards? You certainly can repurpose a wood jewelry box or a beautiful in-box from your desk. You can find a wonderful container in a consignment or antique store. Or you can make your own. Which is what this chapter is all about.

The Expandable Holder

Now that you've started creating cards that represent your inner heroes, you'll want to make a holder that travels well, looks good, keeps the pages secure and—best of all—will hold five or 105 cards. This holder does just that, and it's not hard to make.

You can choose to make this cover from a wide variety of materials including fabric, vinyl and Tyvek. You can find interesting options by looking at place mats, which come in a huge variety of woven materials—wood, fabric, yarn, bamboo. For this piece, I chose a split-wood-and-thread woven shelf liner.

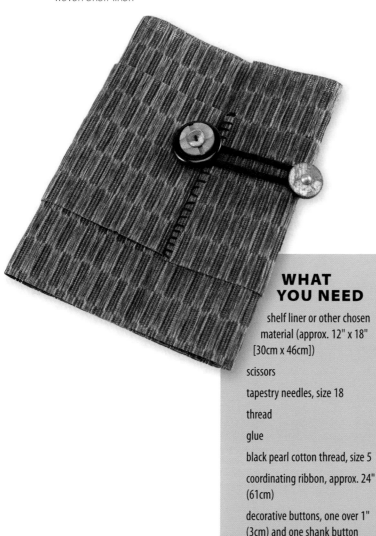

WHAT YOU NEED

shelf liner or other chosen material (approx. 12" x 18" [30cm x 46cm])

scissors

tapestry needles, size 18

thread

glue

black pearl cotton thread, size 5

coordinating ribbon, approx. 24" (61cm)

decorative buttons, one over 1" (3cm) and one shank button less than 1" (3cm)

round elastic, approx 6" (15cm)

Why Loose-Leaf Pages?

With the *Inner Hero Creative Art Journal*, in which all your pages are all loose-leaf, you have some great advantages:

• When you work on a page, you can turn it to work on all sides without the rest of the book pages getting in the way.

• When you use paint or ink, you don't have to worry about smearing the page you have already done and the page that comes after.

• If you want to stitch, you have the freedom to go at any angle you need. A page can be turned or curved to fit through the space between the sewing machine needle and the motor housing.

• Like to use found objects or three-dimensional pieces? Bound books make that hard to do. Loose-leaf pages are made for dimension.

• You can work on several pages at once, putting one aside to dry while you work on another. Starting a page when you need to is a big plus with loose-leaf pages.

• You can experiment on the same paper you work with, and if something goes wrong and you don't want to display it, you don't have to.

• You can create stacks of works in progress, stacks of ideas and stacks of finished pages you love. You can arrange pages to show friends and keep personal ones separate.

• You show as much as you want and hide as much as you need.

• You can work on themes months apart and still keep them close together.

1 Cut approximately a 14" (36cm) length of shelf liner. Use your own pages as a guide to make sure you are cutting the right length and width of shelf liner.

2 Cut about 4" (10cm) off the bottom of the entire length so you have a piece about 8" (20cm) wide. Save the piece you cut off. Turn the cut piece over so you are looking at the outside of the cover. Place the extra piece on top of the cut piece, centering it between top and bottom. Make sure both the side edges of the cover and the cut piece are even.

3 Stitch the two pieces together along the outer edges using a blanket stitch. Start the blanket stitch as shown. Continue stitching the two pieces together, connecting the short edges on one side.

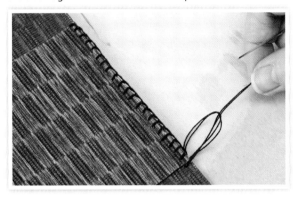

4 Each stitch should be between ⅛" and ¼" (3mm and 6mm) long. Secure the thread by running it through the finished stitching and knotting it on the back side. Add a drop of glue to secure the knot. Repeat the process on the other side, blanket-stitching the short edges together.

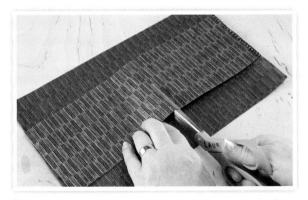

5 Find the center of the narrower piece you just stitched to the larger piece. Cut only this piece in half at this point. This top piece will act as an adjustable expansion joint for however many pages you carry.

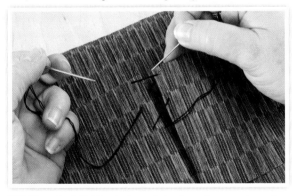

6 Thread a 36" (91cm) piece of size 5 pearl cotton through a size 18 tapestry needle, and then double the thread. Thread the two loose ends through another needle, so you have two needles on one piece of thread. Starting about ¼" (6mm) from the tops of the two cut edges, bring both needles down from the top through to the inside of the split. Begin stitching as if you were threading a shoelace. Once you have the first stitch, use the needle on the right and come up through the bottom of the left side of the split.

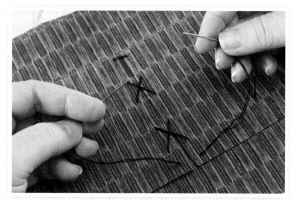

7 Take your left needle and bring it up across from the other stitch to create an X underneath the cover. Both needles are now on top. Continue till the piece is laced together.

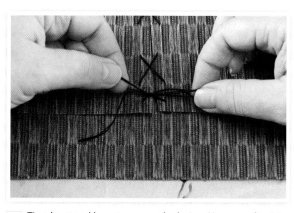

8 Tie a knot and bow to secure the lacing. You can adjust it by loosening it or tightening it to create a snug fit for however many pages you are carrying.

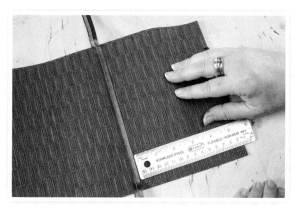

9 Cut a 24" (61cm) length of ribbon. Allow 6" (15cm) of ribbon to hang over the top and glue the ribbon to the width of the inside cover, 6" (15cm) from the short edge. Allow the glue to dry completely. Place your pages on the ribbon and tie it to keep the pages from sliding out.

10 Turn the piece over so the inside is facing you. Measure 3" (8cm) from the right side, and on the outside, sew the smaller shank button. Measure 2½" (6cm) from the left side and sew on the other button so the two buttons are even. Close the cover, and connect the pieces using a piece of elastic. (Hair elastics are perfect for this.)

Buttons

You can create your own buttons from felt, paper clay or polymer clay. You can also stack buttons to create a single button.

Repurposing an Old Book

Libraries often have book sales, and repurposing books is a good way to keep books out of the recycling bin. You are looking for a book with sturdy covers, a binding in reasonable shape and a spine that's thick enough to hold a stash of your pages. If your pages are dimensional, stack up the ones you'd like to keep together, measure the stack, and then look for a book whose spine measures the same or more.

This project uses decorative paper, and the Monsoon Paper project that follows later in the book is perfect for this. You can also use gaffer's tape, sold in photography stores, instead of bookbinding tape, but do not substitute duct tape, which will eventually leak adhesive at the edges.

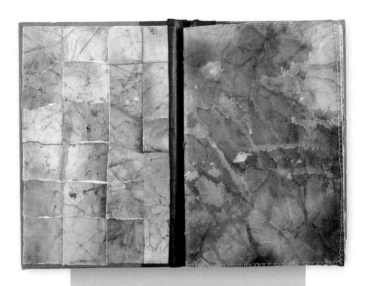

WHAT YOU NEED

hardcover book, large enough to hold your inner-hero pages, with a small margin on all sides

utility knife or small box cutter

Monsoon Papers

glue

book repair tape

bone folder

ruler

scissors

sewing machine/thread to coordinate with decorative paper

tapestry needle, size 18

sea sponge

acrylic paint

waxed linen, 4-ply or pearl cotton, number 8

pencil

awl

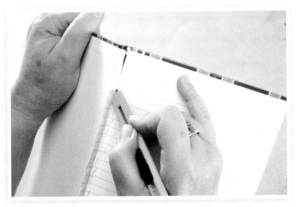

1 Open the book cover until the seam that holds the page block to the cover is visible. Using a sharp utility knife, slice evenly from top to bottom, removing the front of the block. Repeat on the back, removing the book cover entirely. Save for another use.

Strengthening the Spine

In some used books the spine is weak or may have been damaged when you removed the book block. An easy and secure way to repair the book is to use book repair tape (Lineco is one brand). This is a specialty product and most often is one color—black. Some brands also come in white or beige. It's woven cloth backed by an adhesive. Do not substitute duct tape. If you can't find book repair tape locally, cut strips from book cloth and use PVA glue as an adhesive.

Don't limit yourself to old library books. You can also use abandoned journals, cookbooks you will never cook from and gift books you want to display but not read.

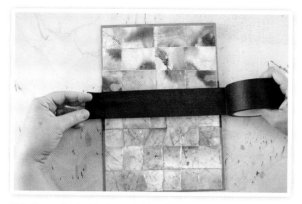

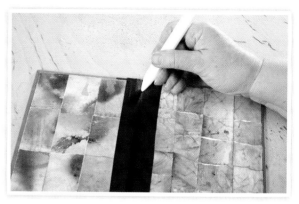

2 Cover the inside front and back covers by using torn pieces of Monsoon Papers (demonstrated next in this chapter) with the photo mosaic technique from the Tarot Reader chapter. (Or use paper of your own choice.)

Tear 1" (3cm) strips along the length of your paper and tear each strip into uneven squares. Starting at the outer edge of the book, glue the pieces down so they overlap each other. Work from top to bottom and from outer edge to inner (gutter) edge. That way, your most uneven pieces will be hidden. Secure the spine and hide the last row of paper squares by covering the inside and outside of the spine with 2" (5cm) wide book repair tape.

3 Cut a piece of tape as long as the book plus 4" (10cm). Place the outside of the book in the center of the tape so the length of the book lines up along the center length of the tape. Place the book down, fold over the top and bottom of the tape by 2" (5cm) and use a bone folder to press the tape tightly against the cover.

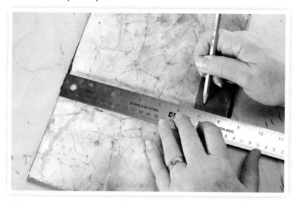

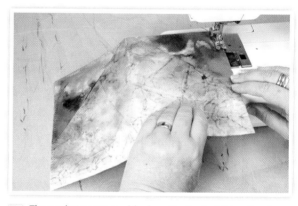

4 Measure the width of the book from side to side and subtract ½" (13mm). Measure the height of the book from top to bottom and subtract ½" (13mm). Cut eight pieces of Monsoon Paper to the given width. The length should be the height plus 2½" (6cm). Fold the bottom of each page up 2½" (6cm) to create a pocket along the whole page. Fold each page in half, short end to short end. This creates all the pages that will hold the cards.

5 The pocket pages are blank on the back. Add a triangle pocket (about 3" [8cm] on each side) on the back side of each pocket page. Glue only two outside edges of the triangle page holder to the page. You now have a pocket on one side of the page and a triangle corner holder on the other. Pockets are good for thick pages, corners for thin pages.

Sew all pages on the outside edges from the top edge down using a decorative stitch. Continue sewing along the bottom of the page and up the other side. This fastens the bottom edge of the triangle and the bottom edge of the pocket on the other side of the page and keeps them from falling open if your page is bulky or heavy.

Ribbon Advantage

Use a thin, decorative ribbon to stitch the pages into the cover. A ribbon allows you to easily remove the inside pages and replace them with different ones. That way, you can create a cover to carry the pages you want to share and have several folders of pages you want to keep private at home. Mix and match covers, stamping them with words that describe the themes, or create a book for each inner hero.

6 When all the pages are sewn, stack them so the center fold has fold-up pockets on the right and left sides. Check to make sure each page has the triangles sewn on the outside edge. Sew the book into the cover, using waxed linen and the pamphlet stitch described below.

Decorate the book cover by sponging the cover to give it a vintage look. Choose three colors of acrylic paint—three shades of one color or a light and dark of one color and gold as the third work well. (See instructions in The Gardener chapter, in the section on decorating the back of the page).

Pamphlet Stitch

1 With your folded paper stack open, use a pencil to make three marks along the crease, one in the center of the crease line and then one above it and one below it, each about 1" (3cm) from the edge of the paper.

2 See that your papers are aligned and are nestled correctly together. Hold the awl in your dominant hand and gently poke until you just see the tip of the awl appear through the outside of the book. Repeat for the other two holes.

3 Cut a length of thread about 24" (61cm) long and thread it through your needle. Thread the needle through the center hole, starting from the outside of the book to the inside.

4 Now thread the needle down through the top hole (number 1 in the illustration) from the inside to the outside.

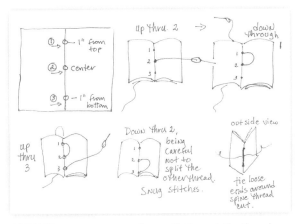

6 Taking care not to run the needle through the thread that's already there, thread the needle back through the center hole (number 2) from the inside to the outside. Pull the stitches snug.

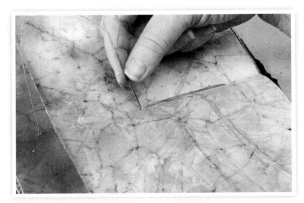

5 Thread the needle up through the bottom hole (number 3 in the illustration) from the outside to the inside.

7 Finally, tie the two tails around the thread that runs the length of the spine. That's it! You have a book to hold your loose-leaf pages.

find fun bonus content from this book at www.artistsnetwork.com/innerherocreativeartjournal.

119

Monsoon Papers

In *Raw Art Journaling: Making Meaning, Making Art*, I demonstrated one method of creating Monsoon Papers. Since that time, I've discovered a few more tricks to update the instructions.

This is one fun process you may choose to use to color your own papers for book covers, accordion folders or for decorative papers to use for making inner-hero journal pages. Coloring your own paper has an advantage: You can choose the colors you like or that match the book.

You can make Monsoon Papers out of different weights of paper for different uses—heavier for accordion folders and lighter weight for inside holder pages for repurposed books.

The papers are named for the summer monsoon storms in the Sonoran Desert, where I live and first developed them. The process of creating Monsoon Papers works best if you are willing to give up control of the outcome. Some papers will be more to your liking than others, but you can save and change the papers you don't like at first. The original Monsoon Papers were made using wind, rain and windblown tree branches. These instructions assume you want the same results without running around outside, dodging lightning and getting drenched.

Before You Start:
- This is not a fast project; leave at least two hours. Dress in old clothes that you don't mind ruining, including old shoes. Wear gloves or a barrier cream because inks stain fingernails.
- Choose color palettes for several different pages. Group the ink bottles so you can grab colors easily without having to sort through them.
- If you're working outside, put the sheets of paper flat on the ground. Spray them until they are thoroughly wet. Flip them over so they get wet on both sides.
- If you're working inside, wet the paper under the faucet. You can get two very different effects if you scrunch up the paper once it's wet rather than if you keep the paper smooth. Try both—one at a time.

WHAT YOU NEED

For outside: water hose with a variable spray head (you will want a fine mist)

For inside: big spray bottle with a variable spray nozzle, large aluminum-foil roasting pan

old clothes (or a big waterproof apron), shoes, gloves (this is messy work)

drying rack to put outside or on a big drop cloth (papers will drip; avoid walkways and areas you don't want to get ink on)

watercolor paper or other sturdy paper, at least 95-lb. (200gsm) text-weight (e.g., Arches Velin)

inks (not alcohol-based) in various color combinations (India inks, acrylic inks or stamp pad re-inkers)

spray water bottle

iron

parchment paper or other clean paper

optional: spray mica inks in various colors

optional: PVA glue

optional: metallic acrylic paint

optional: disposable watercolor brush

1 Wet the paper, crumple loosely and put it in a foil pan with deep sides. Using inks and stamp pad re-inkers (not alcohol inks), drip concentrated color around the wet page. Let the colors sit for a few seconds but not a few minutes.

2 Pick up and unfold the sheet carefully (wet paper tears easily). Spray with a bottle of water, aiming the spray into the ink center. Allow the water to run over the paper into the crinkles. They will be darker. Don't leave any blank spots.

3 Add more ink drops, intensifying areas and expanding your color palette slowly. Success depends on not working too fast. Work on only one side of the paper to allow for thorough absorption. Let go of your need to control!

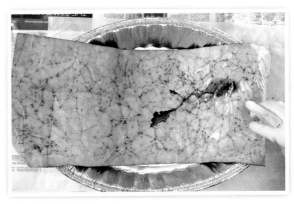

4 If a color is too intense, spray water at close range, allowing the color to rinse over the rest of the paper. If you are working on 100% cotton paper, the color absorption can be controlled only a bit. When one side is done, allow the paper to dry thoroughly.

5 Re-wet the paper with a spray bottle, and apply ink as you did before. The two sides will be different, with a heavily colored and patterned side and a lighter side. The colors used should be similar. Keep gently crunching and adding ink and water. Allow the paper to dry till the paper feels cool to the touch. Then set the color using a hot iron. Protect the iron by using parchment paper over the damp Monsoon Papers.

6 You can leave the papers plain, or you can glitz them up a bit. To add a pearlescent sheen, spritz with a spray ink that contains mica or glitter. Don't soak, just hit a few spots. For an overall elegance, or to upgrade papers you may have overworked, mix a teaspoon of PVA glue with water and a half teaspoon of a metallic acrylic paint to the consistency of light cream. Stir well. Gold is always right. Dip a disposable watercolor brush in the paint/glue mix and rap it sharply on your extended index finger about a foot (30cm) above the paper. The ink flies, so protect your table. Don't overdo it. The gold spatters will distract the eye and make even an unlovely page elegant again.

The Contributing Artist Heroes

Asking people to contribute to your book is both fun and daunting. You are asking them to give up their time and create something specific for your book. In the case of some of the artists, their field is not in the paper arts or necessarily in mixed media. Every contributing artist, however, has a close relationship with the inner critic.

And, even better, each artist was willing to share the story of the struggle with the inner critic so you could see that these creative souls aren't immune from struggle and self doubt.

What all of the contributors have in common is the important knowledge that you are not alone. You are in good company with these special people.

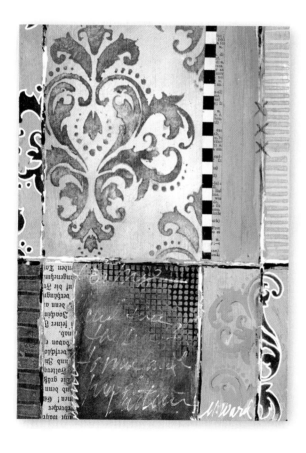

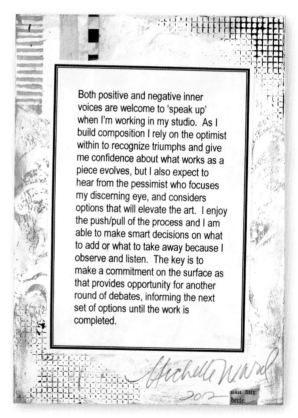

Both positive and negative inner voices are welcome to 'speak up' when I'm working in my studio. As I build composition I rely on the optimist within to recognize triumphs and give me confidence about what works as a piece evolves, but I also expect to hear from the pessimist who focuses my discerning eye, and considers options that will elevate the art. I enjoy the push/pull of the process and I am able to make smart decisions on what to add or what to take away because I observe and listen. The key is to make a commitment on the surface as that provides opportunity for another round of debates, informing the next set of options until the work is completed.

Notes on the Inner Critic:

"Both positive and negative voices are welcome to speak up when I'm working in my studio. As I build composition, I rely on the optimist within to recognize triumphs and give me confidence about what works as a piece evolves, but I also expect to hear from the pessimist who focuses my discerning eye and considers options that will elevate the art. I enjoy the push/pull of the process and I am able to make smart decisions on what to add or what to take away because I observe and listen. The key is to make a commitment on the surface as that provides opportunity for another round of debates, informing the next set of options until the work is completed."

—Michelle Ward

Contributors

Seth Apter from "Bringing Your Inner Heroes Into Your Life"
Seth Apter is a mixed-media artist, author and instructor from New York City. His artwork has been exhibited in numerous exhibitions and can be found in multiple books, independent zines and national magazines. He is the voice behind The Pulse, a series of international, collaborative projects that are the basis of his book *The Pulse of Mixed Media: Secrets and Passions of 100 Artists Revealed*, released in 2012 by North Light Books. He is also the artist behind two workshop DVDs and is currently working on his second book, *The Mixed Media Artist: Art Tips, Tricks, Secrets and Dreams from Over 40 Amazing Artists*, released fall 2013. Visit his blog at thealteredpage.blogspot.com.

Diane Becka from "The Alchemist & Guided Visualization"
Diane Becka has been quilting for thirty years, teaching and winning prizes for her miniature quilts. Trained as an engineer, she has transitioned from a traditional quilter into a fiber artist who layers fabrics and symbolism to tell a story. She finds her creativity is best accessed during her morning walk by the lake, and design ideas come easily there. Diane lives in the foothills of the Cascades in Washington state with her husband and four curious cats. Enjoy Diane's work at dianebecka.com.

Liz Crain from "Storing & Carrying Your Pages"
Liz Crain creates colorful, hand-formed ceramic pieces with strong narratives, expressive shapes and fascinating surfaces.

The current direction of her work explores dented vintage can, pitcher and sand pail forms. She finishes them with ceramic decorating materials using all her 2-D skills and creating the trompe l'oeil look of old graphics, abraded labels and rust.

She holds degrees in studio art, art history and sociology, is an exhibiting member of the Association of Clay and Glass Artists of California and shows her work nationally.

Her studio is in Capitola, California, on the Monterey Bay. You can find Liz at lizcrainceramics.com.

David Dawangyumptewa from "Bringing Your Inner Heroes Into Your Life"
David Dawangyumptewa's path to becoming an artist included stints as a stonemason and lighting roadie for Jackson Browne and Linda Ronstadt. His work is reflective of his Hopi background and Water Clan affiliation. His art has been recognized with awards at the Museum of Northern Arizona, American Indian Heritage Foundation and Santa Fe and Colorado Indian Markets. David has expended great effort to bring art to the public via museum exhibit design, the founding of Flagstaff's Festival of the Arts and high-profile arts advocacy throughout the state of Arizona.

For David, painting is an experience that stresses his individualism, yet connects him with people of the Water Clan of Kykotsmovi in northeastern Arizona. "My paintings reveal myself through consciously developed symbolism, as well as traditional regional life ways. These are images that tell of my loves, family relationships, religious upbringing and observations. The search to deepen an identity as an artist of a centuries-long people of the Americas." David can be reached via e-mail: dawangyumptewa@yahoo.com.

TJ Goerlitz from "The Tarot Reader & Twin and Transform"
Tari "TJ" Goerlitz is an artist who has spent the majority of the last decade living and working in Europe. Since her relocation to the United States, she can usually be found at the

Minnesota Center for Book Arts where she explores letterpress printing. It's the latest component to her mixed-media work, which is a fusion of photography, printing, sewing and journaling. She also marbles paper. TJ is the illustrator for Quinn's "Business of Art" column at *Somerset Studio* magazine. Connect with TJ as she shares her creative journey online at studiomailbox.com.

Rosaland Hannibal from "The Wise Woman & Revisiting Wise Words"
Rosaland Hannibal is a self-taught artist who favors fabric as one of her main types of art media. An adventurous spirit who loves to learn about and explore various art techniques in different media, Rosaland creates with the goal of mixing those media to create unique pieces.

She works in the behavioral health field in an art therapy studio environment that enables her to use creativity to assist others in rebalancing their lives. She keeps her own life balanced with creative and exploratory efforts. You can find her posting mixed-media art to her blog at soulfulcreating.blogspot.com.

Traci Paxton Johnson from "The Gardener & Tool Identification"
Traci is a self-taught mixed-media and fiber artist who finds inspiration in everyday things. "I've always been an artist at heart, but my initial passion was to write . . . write a book!" she says. "I decided I'm probably not such a great writer if I have trouble with *lay* and *lie*, so I moved on to art and haven't looked back."

Traci threw out her corporate career and is relishing her artistic life. She is always experimenting, learning and growing and believes that art is a journey of the soul. Her hand-to-heart connection to nature's elements brings her a sense of calm and allows her to take in beauty and flaws alike. She practices acceptance and sees perfection in imperfection.

Paula Kumert from "Breaking the Ice"
"I have written since before I knew how to write—I remember myself at four doodling a letter warning Robin that Catwoman was up to no good—but never called myself a writer.

"I have played with cameras since I was six (forty years ago it was not usual for a kid that age to own one) but never called myself a photographer.

"I consider my scrapbooks as more of a document than an artistic expression.

"Maybe all of this was my blond Barbie-girl type of inner critic, but I found a loophole.

About a year and a half ago I understood that what I really, really liked were the artists, more than the making of art myself. I find them extremely cool, interesting people. And my blog is a communication tool for me to chat with them. Yes, I show the things I make, but when I really shine through is when I interact with people."

Paula's online name is HappySnappy; visit her in Argentina and her blog at keepitsimplemakeitgreat.blogspot.com.

Margaret Peot from "The Scribe & Freewriting"
In addition to painting costumes for Broadway, Margaret Peot writes books to help people make art-making a part of their daily lives. Her work for adults, *Alternative Art Journals: Explore Innovative Approaches to Collecting Your Creativity* and *The Successful Artist's Career Guide: Finding Your Way in the Business of Art,* and two DVDs, *Alternative Art Cards* and *Alternative Journals With Margaret Peot,* are available from North Light Books. Her children's book, *Inkblot: Drip, Splat and Squish Your Way to Creativity* was awarded a Eureka! Silver Medal for nonfiction books. You can find out more about Margaret's art at margaretpeot.com.

Michelle Ward from "The Contributing Artist Heroes"
Michelle Ward is a mixed-media artist, freelance graphic designer and workshop instructor. She enjoys experimenting in different dimensional art forms but always returns to her favorite thing—working with paper and paint in journals. She is a regular contributor to *Somerset Studio* magazine, and her work can be found in several books on journaling and related paper arts. She has been a rubber stamp designer for over ten years and runs Green Pepper Press from her home studio in New Jersey, where she lives with her husband and their three children. Michelle runs a fascinating art-filled blog at michelleward.typepad.com.

Dedication

For two men who are gone, but live on in my heart: My father, whose frequent advice—"Don't be hasty"— taught me the secret of drawing, and Doug, my father-in-law, who taught me to expect the 18-wheeler.

The Heroes at North Light

Writing a book is distilling the past for use in the future. It takes a long time, a lot of effort and a huge amount of cooperative work to get from the idea to the book. Without the group of imaginative, supportive people at North Light, there would be no book. Tonia Jenny, my editor, is a great supporter of meaning-making and inner heroes, and I owe her a debt of deep thanks for bringing the book to life. Amy Jones, who stood in for Tonia during the photo shoot, had a tough job of being the communication link between the content, the editor and the writer, and did it with grace and ease. Christine Polomsky makes photography look easy, and I discovered just how hard that is. Her talent saved so much work. There are so many people involved in this book, and each one deserves a great deal of thanks for doing their work with care and consideration: Jamie Markle, leader of a great group; Kristin Conlin, video imaginer; Ric Delantoni, video creator; Wendy Dunning and Brianna Scharstein, the imaginative designers; Shawn Metts and Kevin Moran, who put the book in the stores and online; and others I met in passing and almost met.

And finally—thanks to Kent, Ian and my family and friends who have loved me when I was not lovable and believed in me when I could not believe in myself, waiting for me to come around again and tell the stories of the inner heroes I have always believed.

Other fine North Light Books are available from your favorite bookstore, art supply store or online supplier. Visit our website at fwmedia.com.

17 16 15 14 13 5 4 3 2 1

DISTRIBUTED IN CANADA BY FRASER DIRECT
100 Armstrong Avenue
Georgetown, ON, Canada L7G 5S4
Tel: (905) 877-4411

DISTRIBUTED IN THE U.K. AND EUROPE
BY F&W MEDIA INTERNATIONAL LTD
Brunel House, Forde Close, Newton Abbot, TQ12 4PU, UK
Tel: (+44) 1626 323200, Fax: (+44) 1626 323319
Email: enquiries@fwmedia.com

DISTRIBUTED IN AUSTRALIA BY CAPRICORN LINK
P.O. Box 704, S. Windsor NSW, 2756 Australia
Tel: (02) 4560-1600; Fax: (02) 4577-5288
Email: books@capricornlink.com.au

ISBN 13: 978-1-4403-2945-6

Editor: Tonia Jenny
Cover Design: Wendy Dunning
Interior Design: Brianna Scharstein
Photographer: Christine Polomsky
Production Coordinator: Jennifer Bass

find fun bonus content from this book at www.artistsnetwork.com/innerherocreativeartjournal.

INDEX

sign up for our inspiring and free newsletter at www.artistsnetwork.com

About Quinn McDonald

Quinn McDonald helps her clients fan their creative spark into a flame. As a certified creativity coach, she guides clients to discover their creative energy, work deeply and courageously, step into their own power and overcome creative blocks.

Most of her clients, no matter where in the world they work, struggle with the inner critic. Quinn invents ways for people to convert negative self-talk to inspiration by using the medium they work with most often—writing, painting, ceramics, quilting, music and dance.

The idea of the inner hero as creative champion came to her in a dream. She almost didn't write it down. Because she's made and kept journals for years, she decided to take a few notes "just in case." Her inner hero the Scribe gets credit for the idea that began this book.

Quinn is a self-taught artist with a graduate degree in cross-cultural studies. She has spent most of her life as a writer. Letters, words and meaning-making fuel her art. Quinn is curious about life and how creativity lights and warms the heart.

quinncreative.com

quinncreative.wordpress.com